The People of
ORMSKIRK

The People of
ORMSKIRK
Through the Ages 1500–2000

Mona Duggan

AMBERLEY

First published 2011
Reprinted 2011

Amberley Publishing
The Hill, Stroud,
Gloucestershire, GL5 4EP

www.amberleybooks.com

British Library Cataloguing in Publication Data.
A catalogue record for this book is available from the British Library.

ISBN 978 1 4456 0291 2

Typesetting and Origination by Amberley Publishing.
Printed in Great Britain.

Contents

Acknowledgements

Without the help of my many friends in Ormskirk, this book could not have been written. I want to thank so many people who have helped me by giving me photographs from their collections and sharing their memories with me that I cannot name them individually, with the exception of Dennis Walton, who has taken all the modern photographs for me, and June Bibby, who has helped in many other ways. I want to thank the different groups who have supported my search for interesting snippets about the families of Ormskirk: Emmanuel Church members, the Ormskirk Family History Society, the Aughton and Ormskirk U3A, the Ormskirk library staff and the Lancashire Record Office. Without your help I could not have written this book.

All that remains is to hope that the book gives as much pleasure to my readers as it has given to me while I have been writing it.

Chapter One

Life in Sixteenth-Century Ormskirk

Nationally, the sixteenth century was dominated by the actions of the Tudor monarchs, the Reformation and later by the threat posed by Spain and the Spanish Armada – but what was happening locally to the people who lived in the small market town of Ormskirk? It is difficult to find evidence describing their lives, but fortunately some records give us information about a few of the townsfolk – usually those who got into trouble with the law. Among the surviving local records are those produced when the Quarter Sessions met in the town hall, and also those produced after the meeting of the Court Leet – the local court served by a jury that was chosen when the tenants met annually to swear allegiance to their overlord, the prior of Burscough Abbey, and the monarch during the 1500s. At that meeting representatives of the tenants were given various duties such as supervisors of the highways, clerks of the market, burleymen (the enforcers of the court's laws) and other posts connected with the administration of the township, and so we get a glimpse of the social network, the inhabitants' occupations and the standards of behaviour that they set for themselves.

Ormskirk at this time was little more than a small village, although it had been designated a borough for a period during medieval times. Nevertheless, its market attracted both buyers and sellers from the surrounding areas, and inevitably some of the stallholders took advantage of their positions and tried to deceive their customers in one way or another. Two of these stallholders were Peter Jackson and Reginald Mason, who offered bread and beer to sell which were 'not good for men's bodies', and Robert Webster, who brought bad meat to the market. Another butcher, Thomas Morecroft, was accused of overcharging for meat[1] in 1537, and four years later fifteen other butchers were charged with the same offence. Other traders were accused of using incorrect measures when weighing

or measuring their wares; one example of this was Henry Bennett, who measured his salt with the wrong measure. Another similar way of cheating customers was practised by Amy Asmall, who was accused of putting grain into her pepper to deceive people, while the wife of Henry Ambrose was accused of selling bread that was not fit to eat.

All these offences give us a picture of a corrupt market, but actually the market was policed very strictly by officers known as the clerks of the market, who brought anyone that offered inferior goods for sale or cheated in any other way to the Court Leet. Unfortunately, we do not know how many people had stalls in the market at this time, so we cannot estimate the size of the problem, but there were comparatively few offenders when the number of market days covered by the records is taken into account. The court supported its officials and anyone who did not respect them or disobeyed them was brought to court. For instance, Henry Haworth was presented to the court for refusing to accept the measures of the clerk of the market, who must have suspected that he, like Henry Bennett, had also been cheating his customers. In 1599, the wives of Thomas Heyes and of John Eastwood were also presented for disobeying the officer of the market. It is significant that the two women were referred to as 'the wives of' – a sign of married women's complete dependency on their husbands, and also of their husband's responsibility for them and their conduct.

Officials elected to other posts of responsibility were also protected by the court. For instance, Robert Woodman in 1569 and Thomas Glesse and Thomas Heyes in 1599, were all brought before the jury for refusing to obey the orders of the constable. However, much greater fines were imposed on anyone who disregarded the orders of the court itself. For example, both Thomas Morecroft and Thomas Hunter were fined two shillings each for not obeying the court's orders in 1599, and Simon Smith was fined 3s 4d for refusing to serve on the Queen's jury. This was a large sum at that time, for in another case a judge at the Quarter Sessions expected a family to be able to live on one shilling (10p) a week.

Several townsfolk were fined for refusing to accept the posts that they were given by the court. Of course, those posts were unpaid and if they were to be filled adequately, the holders of those offices had to spend a lot of time away from their own occupation, leading to a sizeable reduction in their income. One particularly unpopular post was that of burleyman – the man who had to enforce the court's orders. In 1549, Nicholas Shaghe, Ralph Scarebrick, Thurston Buxton and William Fletcher refused to serve in that capacity and were fined four pence each. In a similar case in 1599, Hugh Haighton refused to accept the post of supervisor of the highways – the task of making sure that people kept the highways clear and repaired them whenever they were called upon to fill in the holes or repair the bridges. Both these last two posts involved making the reluctant townsfolk undertake unpaid jobs, but one post that might have been more popular was that of beer taster. However, in 1549, both John Ireland and John Wyrrall were fined for refusing to take that office. Their duties would have meant going around all

the alehouses and testing the beer to ensure that it met the standards set by the assize. This was an order made by the government during a time of scarcity, which specified the amount of wheat, oats or barley that was to be used in the production of bread or beer.

The court's officials themselves were not immune from prosecution if they misbehaved. For instance, despite being the clerk of the market in the 1590s, Henry Morecroft was fined for breaking the assize of bread and beer. Many of the local people were found guilty of this offence; in fact, altogether thirty-five women, including the wife of Richard Morecroft, were accused of it in 1537. Even the constable could be brought before the court, as was Richard Sankey, a rich mercer, who, in 1596, 'did not beat the bounds of the town according to the ordinance'. This was a process by which the townsfolk, led by the constable, walked around the perimeter of the township to ensure that everyone knew how far the jurisdiction of the court extended. It is significant that even one of the more affluent townsfolk was not immune from prosecution for disobeying the court's orders.

The court was also used by the townsfolk to make sure that contracts were fulfilled and debts were paid. Some of these cases are particularly interesting because they reveal exactly what occupations the townsfolk were following at that time. For instance, Thomas and Ellen Banks were accused of breaking a contract to deliver three clippings of flax yarn to Margaret Carter each day. Evidently, Margaret was a linen weaver, whose neighbours sold her yarn which they had spun from the flax that they grew and processed on their farm. Possibly, they were the tenants of the flax mill on the Ellerbrook, near to the place where Flax Lane, between Lathom and Burscough, crosses that watercourse. The Scutchers' Arms, an inn now converted into a cattery on the corner of Flax Lane and Blythe Lane, was named after those who prepared the flax. Recently, Scutcher's Acres, a new nature reserve, has been opened on the site of the flax fields that bordered the Ellerbrook. The native woodland that has developed on the site probably grew from seeds which fell onto the flax fields when they had been deserted once cotton became readily available.

It is possible that Thomas and Ellen had a stall in Church Street where they sold their yarn on market days. Among the regulations made in the seventeenth century there is certainly an order that anyone buying or selling yarn must only do so between the sign of the White Horse and the Black Horse in Church Street. Ormskirk was one of the centres of the linen industry; in fact, when William Blundell of Little Crosby had the opportunity of putting goods in the *Antelope* on its first trading journeys to America in 1666, he chose to send 3,332 yards of linen for sale in Barbados. No doubt he chose to send linen because it was woven locally by townsfolk such as Margaret Carter, and he could obtain it easily and cheaply in his neighbouring market town of Ormskirk.

The trade in cloth was the subject of several cases brought to the court in the 1540s. In 1545, William Laythwaite complained that Richard Colynson owed him *6s 8d* for cloth, and according to another case, Evan Prescott bought some

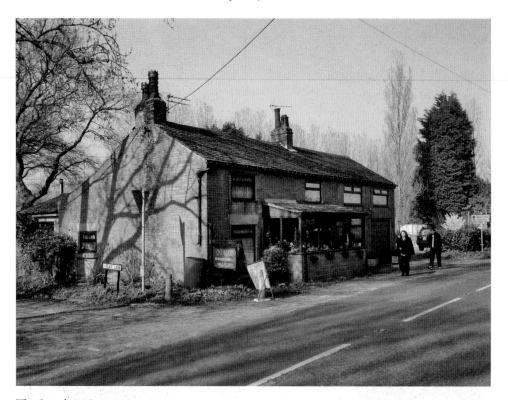

The Scutchers Arms.

'marbled' cloth, probably woven in a mixture of colours, from Richard Nelson for 4s 8d and he too had not paid for it. He confessed that he was guilty and brought 4s to the court and agreed that he owed 4d but no more. The court accepted his plea but fined him 3d. A third case concerned Dulcie, widow of Richard Bostock, who complained that Thomas Gerrard kept cloth – red galen – worth 1s 9d that was rightly hers. Presumably, during the case, Thomas must have agreed to give her the cloth for he was only fined 3d. Unfortunately, the records do not specify whether the people involved had actually woven the cloth or whether they were merely retailers. It is very possible that the cloth had been made by local handloom weavers working in the small thatched cottages that lined the streets of the town. The 'marbled' cloth may have been dyed locally, for there was a dye works in Dyers Lane where the brook provided water for the process.

Workers in the leather industry also appear regularly in the court records. In 1596, Robert and John Mollineux, William Naylor and Edmund and Peter Lee were accused of selling badly tanned leather in Ormskirk. This complaint was often made against the tanners of Ormskirk, but again it was part of the Court Leet's campaign to keep the market in Ormskirk beyond reproach. During the next century, the court appointed searchers and sealers of leather, who went around

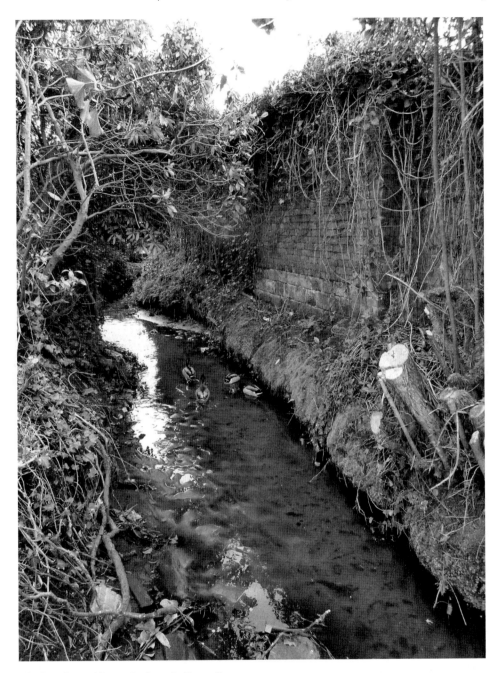

The brook used by early dyers in Dyers Lane.

the workshops and market stalls to test the leather to ascertain that it had been tanned properly and put their seal upon the products that met their high standards. Although we do not know exactly where the tanneries were in the sixteenth century, they would be on the edge of the town where the pits could be sunk, and where the smell from the process would not be too offensive for the townsfolk. It is not until the eighteenth century that the location of a tannery is specified, and that was in Burscough Street, behind what is known today as the Brandreth House. It is very possible that the site had been used for tanning throughout the preceding centuries, for it was an ideal location. There was a stream nearby that would have provided water for the process and would have washed away all the waste products. Leather working of every kind flourished in the town. Everything from gloves to saddles, and from shoes to harnesses, was made in the small workshops along Moor Street and Aughton Street.

The size of the leather industry is reflected in the number of butchers selling meat in the town. Alongside the old town hall in Church Street there was an area known as the shambles, where many of the butchers had their stalls. There, all kinds of animals were brought to be slaughtered to provide meat for the butchers and skins and hides for the tanners. Again the court records give us a glimpse of the animals that were common around the town at this time. It was recorded that in 1538, Thomas Morecroft and Reginald Wainwright had bought a pig from Margaret Raynsorth for 5s and had not paid her, and in the same year William Wolfe accused Damden Evan of allowing his pigs to eat William's corn. Pigs were kept by many of the cottagers in their small gardens, both to provide food for themselves and pigskin for the tanners. The pigs also provided another source of cash for the cottagers, who were able to sell any piglets that were born. In fact, in 1550, Hector Prescott accused Thomas Prescott of not paying him the 2s that he owed for piglets. It is possible that these had been sold in the market together with the many other animals that filled the streets of the town on market day and at the fairs. This became a problem and later it was decided to create a market exclusively for the sale of pigs on land behind the properties on Moor Street, on the site of today's Wheatsheaf car park.

Sheep were the cause of a long-standing disagreement that ended in the court. In 1549, Alice Atherton accused Peter Burstoghe of trespassing and also said he killed one of her ewes that was worth 3s 4d. She claimed compensation, but he disputed that and said the ewe was of no value. However, the court disagreed and decided that it was worth 10d. Evidently that was not the end of the matter, for a year later they both appeared in court again. This time Peter accused Alice of allowing her ewes to trespass and destroy his herbage and grass to the value of 4s. She denied it, but this time she was found guilty and fined 3d. A more serious charge was made against William Butcher in 1537, when his calves trampled down the corn in the town field, which was north of the town on the land bordered now by Derby Street and Burscough Street. That field was divided into strips that were cultivated by the townspeople, and so the corn that was damaged belonged to all the inhabitants.

Consequently, William was fined 3s 7d, a large sum that reflected the harm done to the town's crop of corn.

Pigs, sheep and calves were not the only animals to be seen around the town. There were also oxen working on the neighbouring farms, pulling carts into the town and also being sold in the market place. They were valuable assets and when Reginald Wainwright bought two oxen from John Urmston in 1538, he agreed to pay 31s 4d for them. However, he gave John only 20s, and so the matter was brought to court and he was ordered to pay the full amount. Some of the more affluent inhabitants had horses, which, of course, were worth a lot more than the oxen. Perhaps one particular horse cost more than one ambitious townsman, Robert Upwilliam, had anticipated, for in 1541 it was claimed that he 'still owes 9s 6d of the great sum he paid for a horse' he had bought from Miles Sadler.

This was such a serious matter that Miles employed Adam Bretell, an attorney, to plead his case and he was successful in receiving the payment. No doubt there were attorneys living and working in the town, for both the Court Leet and Quarter Sessions were held in the town hall. Nevertheless, on a map that was produced in 1609, there are no particularly large houses shown where professional people such as the attorneys might have lived. The only house with three storeys stood in the centre of the town, facing the cross, but we do not know who lived there at this early date. Maybe it had been the town house of the lords of Lathom many years ago. It is possible that the more affluent people lived in cottages with more than one bay and a few examples of those do appear on the map.

When the Quarter Sessions came to town, local lawyers were sometimes called to present cases to the judge, who used to try the more serious cases. However, they were seldom called upon to represent defendants in the Court Leet, despite the fact that the court dealt with many, many cases of fighting and wounding. There was a very rough and aggressive group in the town, several of whom belonged to well-respected families, including members of the Morecroft family – Richard, James, Ormsfried and Edward – and Henry Sutch, Richard and William Swift, John Lythorne, James Harrison, William Molyneux, Cuthbert Gerrard, and John and Ralph Whitestones. These were serious attacks, and in many cases they injured one another or 'drew blood'. In addition, there were women, among whom was Anna, the wife of Ralph Whitestones, the wife of George Easthead and the wife of Thomas Laythwaite, all accused of quarrelling with each other in many places in Ormskirk in 1574. A picture emerges of these women following each other around the town, screaming abuse at one another. Ormskirk was not a quiet, peaceful place in those days. The effects upon the townsfolk of the Reformation and the Dissolution of the Monasteries may have been responsible for some of these disturbances.

The closing of Burscough Priory must have had a devastating effect upon the town, which had been controlled by the prior ever since the twelfth century. One townsman, James Shirlatter, was described as being a chaplain in 1537, although he is not recorded as being the vicar of the parish church, nor is he described as a priest.

A sketch of the large house from the 1609 map.

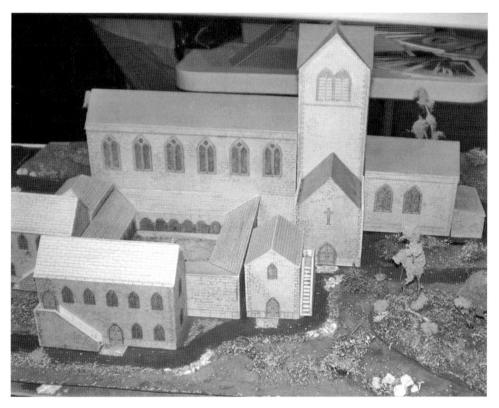

A model of Burscough Priory before its Dissolution.

The chaplain drew blood on David Eden during a fight, possibly caused by disagreements resulting from the Reformation, and it would seem that Richard Morecroft in his role as constable had tried to stop the fight, only to be assaulted by David. Whether a larger fight erupted following that attack or whether another fight developed later is unclear, but ten local men, including Thomas Leatherbarrow, Ralph Fazakerley, Ralph Asmall, Edmund Eliot, and Thomas Prescott, were accused of being involved in a fight in the same year. Even the women were not immune to these attacks, for Ellen Banks was involved in some kind of disagreement with the same chaplain and he was accused of hitting her. Feelings must have been running very high at that time, and it may have been religious tension that was indirectly responsible for all the trouble. This may also have been to blame for the vicar, Richard Ambrose, being presented in court in 1588 for the minor offence of putting dung next to the wall of the church – not a very sensible thing to do at a time of increased religious sensitivity. Later in the century, four townsmen were accused of having bad women who were suspected of being converts in their houses. It would seem that in the opinion of the court, women who were converted to the Protestant faith must be bad, or maybe, in a mainly Catholic town, it was thought that only bad women converted to the new faith.

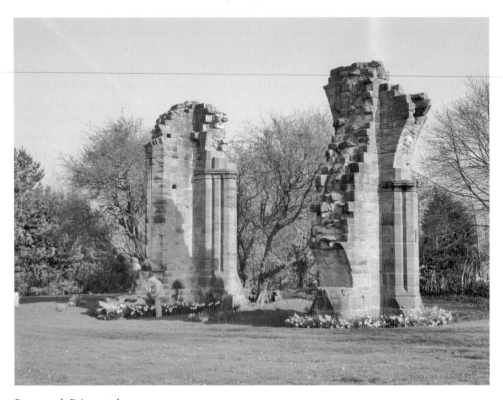

Burscough Priory today.

The male jury seemed ready to denigrate women without much evidence. For instance, Joanna Whitestones and Alice Haresnake were described as 'two ill-disposed women' whom Richard Whitestones was accused of bringing into his house in 1537. No evidence was recorded as to why they deserved that description. Then, in 1552, an order was made that anyone who received Alice Hesketh, Johana Prescott, Amy Holland, Isobel White or Jenett Brokefylde at night would be fined one shilling by the court. Again no reason is given for the ban, but, of course, Ormskirk was a small town and perhaps their reputation was well-known. Nevertheless, the court did not hesitate in describing Margaret Morecroft, wife of Gilbert Morecroft, as a petty thief who nobody in Ormskirk was to receive. If they did, they were to be fined 6s 8d. It would seem that she was to be sent to Coventry by the townsfolk. Throughout the century, there are instances of men being presented at court for receiving 'evil doers' or persons of bad behaviour in their houses and being fined sums varying from 4d to 6s 8d. However, when they received vagabonds the fines increased to 10s. A possible explanation of this differentiation is that the 'evil doers' were known inhabitants of the town, whereas the vagabonds were unknown strangers who had come into the town, perhaps suffering from poverty. Consequently, the fines were high to prevent such people staying in the town and becoming a charge to the community.

Another group of men were brought to court on charges which seem very alien to us. They were the men who played prohibited games with servants, apprentices or sons of various neighbours in their houses. It all sounds very innocent, and nowadays it would be very acceptable for the young people to play games in neighbour's homes. It depends upon what exactly was the nature of these illicit games – possibly gambling games or sports involving animals. Cruel sports which would be prohibited today were enjoyed legally by the townsfolk; in fact, several of the inhabitants, including William Morecroft, William Moyneux, Roger Barton, Miles Bowton, Edward Porter, and Hugh Shaw, were accused of keeping 'dogs called mastiff dogs unmuzzled'. The main reason for keeping dangerous mastiff dogs would have been for baiting bulls or bears, and, of course, uncontrolled mastiff dogs roaming around the streets would have been a real danger to the townsfolk.

Although all this activity suggests that Ormskirk's inhabitants lived in an urban environment, the countryside was very close to the centre of the town and the people had close ties to the land. As we have seen, the town field was cultivated in strips by the inhabitants and east of that field was the large Greetby wood and quarry, which is perpetuated today by Greetby Hill. In fact, the woodland was still in existence in the nineteenth century when the Ormskirk to Skelmersdale railway was built across the site. Seemingly, the lord of the manor issued licences that enabled people to take wood from that plantation for their own use, and in 1552 Ellis Anderton and his wife were accused of taking wood without a licence. Earlier, in 1537, Richard Beretagh had cut down many oaks in Greetby wood and later, Nicholas Formby and William Barker used some timber from the woodland to make ladders, which they sold to Adam Morecroft and Richard Mast. There was some confusion as to how the two joiners got the timber. They maintained in court that they found a young oak in a ditch between the tenement of Henry Wainwright and Greetby wood and had removed it, suggesting that their motive was purely to keep the watercourse running freely. Nevertheless, the court had doubts about the origin of the oak timber and it was left to the jury to decide whether the joiners had any right to the wood.

There were small farmsteads on the edge of the town, where a few cows were kept and cereal crops were grown. In addition, cheese was made for sale in the market and barley was grown to be processed into malt. In 1538, Peter Carter was accused by John Morecroft of breaking his contract to repair a malt house, but exactly where the malt house was situated in Ormskirk is unclear. Certainly Green Lane was the site of a malt house in the nineteenth century, and maybe that was the traditional site. Many townsfolk also kept pigeons for food, and in 1598 the court fined Richard Wirrall 4s for retaining a pigeon that belonged to Thomas Wainwright.

The inventory compiled after the death of Bryan Morecroft in 1589 gives us some idea of the standard of living enjoyed by the more prosperous farmers who lived in Ormskirk.[2] When he died, he left a few animals: two young heifers, nine

sheep, two young pigs, four hens and a cock, and some ducks. The most valuable item in the list of his possessions was the large quantity of barley and oats, some already threshed and some not, which the assessors valued at £3 10s 8d. No doubt some of that was destined for the market, but much would be needed by the family for food – and drink. It is certain that he had equipment for brewing his own beer. He also had a spinning wheel, but no loom, so his woollen yarn must have been sold on the market to the local handloom weavers. There was also hay valued at 13s 4d for the animals during the winter months and four flitches of bacon that made certain the family and servants would not starve. According to his will, he had three children, Edward, Ellyn and Jane, but it is unclear how many servants he kept. However, the amount of bed linen that was listed by the assessors suggests that several people slept in his house. He had ten coverlets, four old blankets, nine pairs of sheets, as well as other bedding, a bedcloth and bolsters. Unfortunately, the bed stocks were valued together, so it is not possible to count the number of beds. Similarly, it is difficult to assess the number of pewter dishes he must have possessed to make the weight of fifty pounds as listed in the inventory, but that also suggests that several people lived on the premises. Perhaps each member of the household had his own pewter spoon, for ten pewter spoons are listed separately, and maybe the three silver spoons were only used by special guests. Finally, there was a touch of luxury in his four cushions worth one shilling and in the 'apparel for his ladie', which was valued at 13s 4d. It is significant that Bryan's wife is described as his lady by the assessors, suggesting that she was in a class above an ordinary farmer's wife. He was certainly one of the more wealthy people in Ormskirk, for a total of thirty-two people are listed in his will as owing him various sums of money. One of these, John Cropper, owed him for one part of a fat cow that they had bought from Nicholas Walsh. Buying a cow must have been one of the most costly expenses for a farmer; in fact, Bryan Morecroft himself owed 45s 4d for a cow that he had bought from Gilbert Ormesher.

Several of the Morecroft family achieved high status, both in the court and in the Church, during the sixteenth century. Henry Morecroft was awarded a BA at Oxford in 1550, and seemingly continued to study to become a physician. He married Jane Gorsuch at St Michael's church in Aughton in 1561, and three years later Jane's widowed mother sold a house and lands in Scarisbrick and Martin to the couple. It is likely that Jane came from Gorsuch Hall, near the southern entrance to Scarisbrick Hall, on the lane that now bears that name. Henry worked as a physician in the Ormskirk area and was mentioned in both the wills of Richard Halsall, the parson at Halsall church, and, in 1572, of Edward Stanley, 3rd Earl of Derby. The fact that the earl left £20 to his son Ferdinando and the large sum of £10 to his servant, Henry Morecroft, shows the high regard in which Henry was held by the earl. In fact, he later accompanied Henry, 4th Earl of Derby, to France when the earl was appointed by Elizabeth I to present the Order of the Garter to Henry III. As the physician to the Stanley family, Henry Morecroft was part of the retinue and so enjoyed the fortnight of festivities that followed the presentation in January 1584/85.[3]

A wedding brought Gilbert Wright to court in the 1560s, when he became involved in a dispute with his wife – or possibly wives. Gilbert told the court that 'he had communication with Margery Barton, as yonge folks are used to have; but never they made contract or troth plighting'. He admitted that in the back garden of William Asmall, he had told Margery that he would marry her and no other, and Margery had replied that she would marry him and no other. Elizabeth Meols was present in the garden and confirmed that his account was true and said that Gilbert declared, 'I take thee Margery to be my wedded wife.' Elizabeth said that, on seeing them hand fast and troth plighted, she thought it was enough, but Gilbert sent for a clerk who brought a bible, and Gilbert swore upon the book, saying he would never take another woman. They kissed and went into the clerk's house, where they all dined together. After that she said, 'all the country thereabouts Ormskirk that knew the parties' took them for man and wife before God.

However, there was another Elizabeth, who believed that she was Gilbert's true wife. She told the court that she had been married to Gilbert in Formby Chapel by the curate. She admitted that no banns had been called, nor had they obtained any licence. When she was asked why they had not been married in their own parish church in Ormskirk, she replied that her friends did not want her to marry Gilbert, so they had gone to Formby. The judge was asked to decide whether the old traditional marriage or the unofficial marriage in a chapel was to be accepted. Elizabeth claimed that she did not know that any other woman had any 'title or claim … against him', and if she was not proved to be his lawful wife, she would 'be content to do that which shall be thought reasonable'. I wonder which wife won the day.[4]

Thus a picture emerges of the small township bustling with activity. There would be tiny workshops bordering each of the four main streets with craftsmen fashioning all kinds of goods for sale, both from their homes and in the market. Glovers, saddlers, weavers, spinners, tinsmiths, joiners, bakers and butchers would all be following their trades, while people passed by, intent on buying produce of all kinds in the market place. Other people, many of them bearing surnames that still exist in the town, would be exchanging news and gossip with their neighbours. The township was so small that they would know one another, and would share their joys and their worries with one another, especially when the status quo was altered by the Reformation. National events may have happened a long way away, but their repercussions were felt locally, causing quarrels among the townsfolk, some of whom seemed only too ready to fight and cause trouble. Meanwhile, on the edge of town were the small farmsteads, peaceful scenes of sowing and reaping and caring for animals, settings which are repeated today, but on a very different scale.

Notes

1. The cases that came before the Court Leet in the 1500s can be found at the National Archives, reference numbers DL 30/79/1060 – DL 30/79/1073.
2. Lancashire Archives, to be abbreviated to L.A. in other notes. WCW Bryan Morecroft, 1589.
3. I am indebted to Wendy Moores for this account of Henry Morecroft's life.
4. Furnivall, F. J., *Child Marriages, Divorces and Ratifications in the Chester Diocese 1561–1566*, Early English Text Society, 1893.

Chapter Two

The Townsfolk during the
Troubled Times of the Civil War

When we look at the portraits of Queen Elizabeth I, dressed in clothes made from rich embroidered fabrics, she seems to belong to a different world to that of the townsfolk of Ormskirk. However, the local mercer's inventory, taken after his death in 1613, would suggest that local people also dressed in expensive clothes made by local dressmakers and tailors. Indeed, many imported fabrics were included among the ninety-six different articles listed in the shop that belonged to Roger Sankey. Taking account of the range of articles in the stock, his shop could almost be described as a department store.[1]

The drapery 'department' stocked all kinds of expensive materials, ranging from ambrosias, which were silk dress fabrics made in France, to Spanish satin, and included taffetas, damask embroidered with branches, and various kinds of velvets, both plain and what is described as 'sparke' of velvet, which was velvet with gold threads. There were other, more substantial, cloths such as broad cloth, western kersey, baize and Kentish cloth, valued at different prices according to the colour – tawny was worth 9s, while blue was only worth 8s 6d a yard. A woollen fabric made in Norwich was on sale for warmer clothes, while working clothes were catered for with buffyne, a coarse cloth, or with fustian, a mixture of wool and cotton. Then there were all the accessories: silk buttons for cloaks, gold buttons, inkle or tape, copper lace, narrow and broad velvet lace, and lace of a breadth that was fixed by statute and fringes of all colours. Interestingly, both the lace and the fringes were sold by the pound. Normandy canvas was listed, possibly used for making corsets, or for stiffening the elaborate bodices of the ladies' gowns. Tufte canvas also appeared on the list, alongside sackcloth and another type of cloth which the appraisers dubbed as 'mouse coloured stuff'. All these fabrics were intended for sale to the inhabitants of Ormskirk, not to the ladies of the court. No

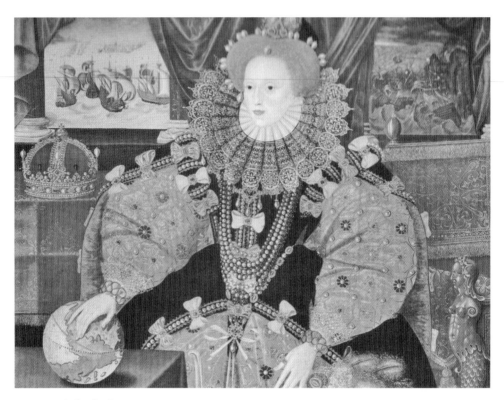

Portrait of Elizabeth I.

doubt Lady Derby and her close friends would buy the fabric for their clothes in London, but the farmers' and craftsmen's wives would buy their materials from Roger Sankey. Evidently he imported some materials directly from the continent, for there were goods at Liverpool waiting for collection when he died. These expensive materials were also used as furnishing fabrics, as in the Sankey parlour where there was a stool covered with that velvet with gold flecks. Obviously, it is a great mistake to imagine that the inhabitants of the town would always be dressed in homespun, dowdy clothes. There was one article listed in the loft over the parlour which shows that even the most successful draper had some unavoidable disasters. There, hidden away, were four yards of moth-eaten green cloth.

There was also the 'department' that catered for the scholars or townsfolk who had received a classical education. There were eighteen primers – simple text books, five Greek grammars, two Aesop's fables, possibly in the original Greek, four Terrences and four Catoes, one Latin book, a psalter and four Nowell catechisms. It is surprising that these books were stocked in Sankey's shop, because at that date there was no grammar school in Ormskirk. However, a schoolmaster was buried in the town in 1590, but little is known about him. Of course there may have been monks from Burscough Priory who had come to live in Ormskirk

when the priory was closed, and taught Latin and Greek to those children whose parents were able to pay for the privilege. It is also possible that the vicars, Eliseus and Richard Ambrose, taught grammar in the parish church and took lessons in their religious faith using the catechisms and psalters, but there is no record of that happening. Greek and Latin were essential if the children were hoping to be admitted to Oxford or Cambridge with the intention of following a career in either the Church or the law. As far as Roger Sankey himself was concerned, there were no Latin or Greek books listed among his personal possessions, but he did own a 'great old bible' and a little prayer book called *Poore Man's Rest* – an odd title for a book belonging to one of the richest men in town.

Listed in the inventory of the shop were two horn books, which must have been provided for the local children who were learning to write. Also among the stock were twenty-four ink horns, which suggest that many of the customers were able to write. As writing was taught only after reading had been mastered, it would seem that many of the townsfolk were fully literate. Certainly Roger Sankey valued education, for he was one of the people who supported the building of a grammar school in the town. Although Henry Ascroft, the chief benefactor of the grammar school, had died leaving money for its foundation in 1601, nothing had been done to establish the school when Sankey made his will in 1611. Consequently, he included a grant of £6 to be paid to the governors for the school when it was 'builded and a master teaching in the said school and not before', a dry comment on the tardiness of Ascroft's executors.

Another 'department' of the shop provided all kinds of things that would be needed by the craftsmen and traders of the town. There were sparrbills for the thatchers, boulter, a cloth used for sifting by the millers, as well as white lead, yellow wire for cythren strings, gum Arabic, steel, pitch, resin, quick silver, brimstone and even gunpowder for various other tradesmen. We can only guess what uses would be made of these products at that time. Then there were the more usual things, such as nails, glue, turpentine and sealing wax. Two swords were for sale, possibly for those who served in Lord Derby's troop, while a pair of old virginals were available for some aspiring musician.

The grocery 'department' stocked all kinds of spices and ingredients, such as currants, pepper, powder sugars and caraway seeds, for baking. Brown and white candy and comfits suggest that children and adults with a sweet tooth were not forgotten. Whether the wormseed was intended for human consumption or for the animals is not clear – perhaps it should be included in the pharmacy 'department' of this store.

The appraisers went from room to room in Roger's house, describing and valuing all his possessions. Everything from the 'wooden vessel to wash cupps in' and the chopping board to the seven feather beds, and from the twenty-seven napkins and the three women's gowns to 'a saddle for a woman with a bridle cloth', was listed and priced. He had two barns, one alongside the street and another at the back of the house, and yet he had only one heifer and two cows. Seemingly, he intended

to build an extension to his house because 20,000 bricks, 28 pieces of wood and a quantity of dressed stone were stored in one of the barns. This may well have been the beginnings of the great rebuilding that took place in the town during the seventeenth century, when most of the old clam, staff and daub buildings with thatched roofs were replaced by brick houses, so that by 1754, Ormskirk could be described by the traveller Dr Pocock as being mostly of brick and 'more like a Dutch town than any place seen outside Holland'.[2]

It would be interesting to identify exactly where Sankey's shop was located in Ormskirk, but, of course, such details are seldom given in old documents. However, the 1609 map of Ormskirk included among the legal documents supplied by Lord Derby to support a case that he presented in the court of the Duchy of Lancaster may provide a clue. This concerned four people, including Roger Sankey, who had claimed to be freeholders and charterers in Lord Derby's manor of Ormskirk. The earl declared that 'without any right [they] have entered and intruded upon waste grounds [roadways] of the manor and erected and builded divers houses, edifices and buildings to the great annoyance of the rest of the inhabitants'. Consequently, he was claiming rents for the amount of land that they had appropriated.[3]

The case describes the property that Roger had built out onto Moor Street: 'a brick wall in length with the street twenty yards and in breadth into the street three yards, and one stone chimney', and also a house (meaning a kitchen) sixteen yards by four yards and a shop or workshop five yards by two yards. This suggests that he had extended his main living room out on to the roadway and had built a stone chimney for that new room. Then he had built a kitchen alongside, but separate from, the main building to guard against the danger of fire, a usual practice at that date, while the workshop was intended to be a place where his employees could make things for sale in the retail shop. It is very difficult to identify that property on the map, but a similar site with the initial 'n', denoting a new extension, is drawn more or less where the old Ship Inn stood. It may be that his house and shop were later converted into that inn. Now Clark's shoe shop is on that site, and indeed the building line still extends towards the roadway around that property today.

That is also true of the extension Roger had built into Church Street on the property that he had inherited. He had built part of a cross chamber out on to the roadway, which was 8 yards by half a yard, and a second, similar chamber, which was 5 yards long and 1½ yards wide. The chamber was built with the gable end towards the street so that it could extend down the burgage plot belonging to that property. On the map, the two properties identified as new extensions are on the site of the present Specsavers shop, and again the building line still alters at the relevant point and veers out towards the roadway.

Despite all his wealth, Roger had a difficult family life. Two of his wives died, Ellen in 1582 and Ann in 1592, and also several of his children, leaving only Jane, his third wife, and his three children, Richard, Margaret and William, to survive him. His son, William, had been a great disappointment to him, and in his will he described his son's behaviour in no uncertain terms. Roger declared that William

The Ship Inn site today, showing the building line.

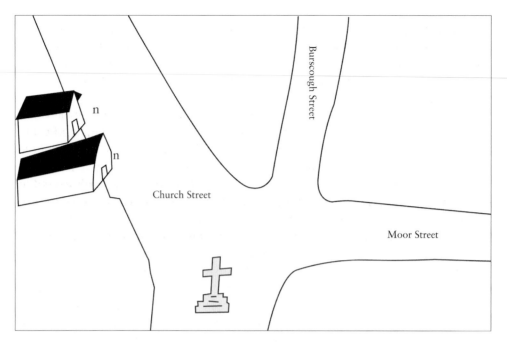

Sketch of the possible site of Roger Sankey's house in Church Street from the 1609 map.

The Church Street site as it is today, showing the change in the building line.

did 'prodigally spend and wastefully consumed a great part of my goods and stock within my shop, also has followed and frequented most wicked, idle and lewd company to his own shame, discredit and overthrow and my greatest grief'. Nevertheless, he left him his fair share of the property once Richard had taken over the business.

The other three men accused of extending their property on to the roadways were Hugh Fletcher, Bartholomew Hesketh, or his son Gabriel, and William Laithwaite. The extensions made by Hugh Fletcher were on Moor Street and consisted of one house with a frontage of 9 yards and extending out by 3 yards that was in the tenure of William Sutton, and two cottages with a frontage of 24 yards extending out by only 1 yard. Again it is difficult to pinpoint these houses on the 1609 map, but there are two cottages and a slightly larger property drawn approximately on the site of the present bus station that have the initial 'n' written alongside them which may have belonged to Hugh. Alongside that property on the map are more houses marked with the initial 'n', and these were probably the houses built by the Hesketh family which extended 8 feet into the carriageway. It is significant that these were the last houses on Moor Street, or Wigan Road as that section of the street became later. The map shows only open fields beyond that point, so those houses form the boundary between the town and the open country at the beginning of the seventeenth century, and mark the gradual spread of the small township into the fields towards Westhead.

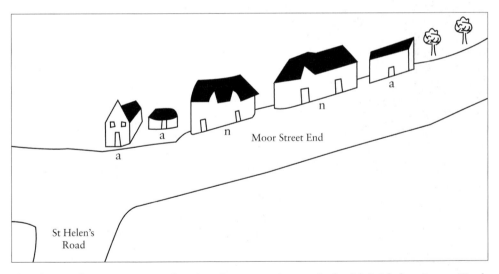

Sketch map from 1609 map showing the properties marked with 'n' belonging to Hugh Fletcher and the Hesketh family that were the subject of the case. The letter 'a' indicates ancient properties.

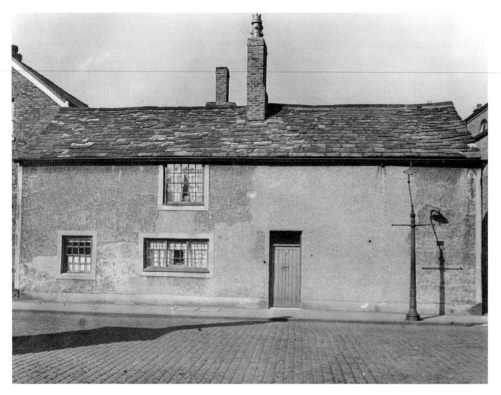

This old photograph shows a cottage on Moor Street that may have belonged to Hugh Fletcher.

Hugh also extended a building with a frontage of 24 yards extending 8 feet into Church Street (called Kirk Street in the document). This would be the new extension marked on the map towards the top of Church Street, approximately lower down the street from the site of today's Tesco, where again the building line alters out towards the roadway.

The fourth defendant, William Laithwaite, was accused of building a barn out onto Moor Street, and again it is unclear where that was. However, in 1677, during a case at Chester Consistory Court, Jane Laithwaite, wife of James, the son of William, stated that the family had lived in an ancient tenement in Aughton Street near the corner of Moor Street for several generations, so it is likely that the barn was an extension of that property extending back into Moor Street. By 1670, John Entwistle had bought the property and pulled down the lower part of the house and a smithy that stood next to the building, and he had also demolished another small, thatched building nearby, 'where poorer people lived'. Then he built a house that was 'the best and most principal house in Ormskirk', by then probably occupying the whole of the Moor Street–Aughton Street corner site.[4]

It is interesting that during the same Chester case, one of the witnesses said that in the early years of the seventeenth century William Laithwaite sold ale, and that

Church Street showing the alteration in the building line lower down the road from Tescos.

his inn was frequented by Sir Richard Molyneux. In fact, that inn on Aughton Street near the corner with Moor Street was leased by William Laithwaite from Richard Sankey in 1624. It was the predecessor of the nineteenth-century Fleece Inn in Aughton Street, the property which is now the Ormskirk branch of Barclay's Bank.

The Chester case mentioned above concerned the right to a pew in Ormskirk parish church which had been the source of some scandalous behaviour in the church. Jane Laithwaite asserted that her family had the right to a space, 10 feet 6 inches by 6 feet 3 inches, on the east side of the middle pillar, where they had their own pew and burial place. However, when the property in Aughton Street passed to the lawyer, John Entwistle, he claimed that the right to the pew belonged to the property, and so to him and his family. This was contested by Jane, but nevertheless John pressed his case by employing Richard Beesley, a stone mason and a Quaker, to remove the ancient inscription on the gravestone over the Laithwaite grave and inscribe 'J. E.' on it. Then he told his apprentices and servants to sit with his family in that pew whenever they went to church. One Sunday, James Ashworth, John's apprentice, and Thomas Wainwright arrived in church before Jane arrived and sat in the pew. When she came in, she stalked up to James and 'did pull and

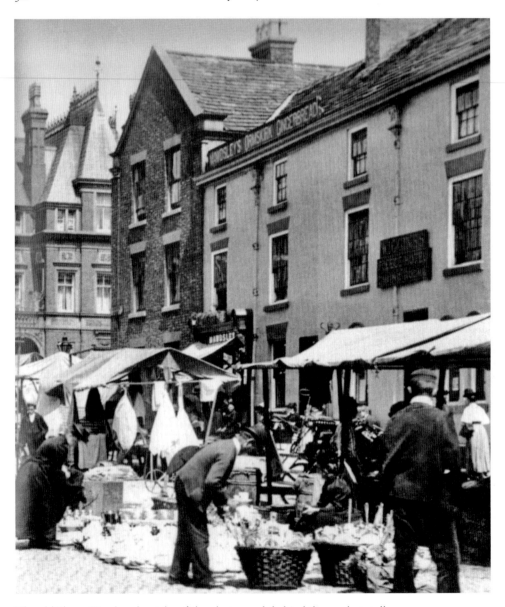

The old Fleece Hotel at the right of the photograph behind the market stall.

Barclays Bank today.

thrust' at him and 'would have pushed him out, but could not and talked lewdly to them both'. The 'congregation was disturbed and many people stood up and stared at them and she pulled an instrument or thing out of her pocket like a bodkin and thrust it several times' at James, who 'put it by with his hand'. Another two Sundays passed and the two men were again threatened by Jane; then, on the third Sunday, she told James 'that before he should sit there she would have his life and she would bring chamber pots and throw them in his face'. She finished her tirade by saying that his master and all his family were '[?] … and lousey beggars all of them'.

Jane was also involved in a case concerning the establishment of a sugar refinery in Ormskirk in 1676.[5] By then she was a widow, and within the last decade of the century her son-in-law, Henry Barton, had become the innkeeper. Once the inn had been sold to John Entwistle, Henry looked elsewhere to invest his money, and decided that there was a lot of money to be made in the new industry of sugar refining, using supplies of raw sugar imported through Liverpool from the West Indies. He contacted John Woosey, a sugar boiler, whose father had an inn at Four Lane Ends in Bickerstaffe, and asked him to join him and his mother-in-law, Jane Laithwaite, in this project. John was slightly reluctant, but eventually an agreement was reached. The Bartons and Jane Laithwaite promised to 'furnish

A photograph of the interior of the parish church showing the possible site of the Laithwaite-Entwistle grave.

[Woosey] with a house made fit and convenient for carrying on the work of sugar baking and boyling and also should furnish [him] with sugar, fire, moulds and all other materials needful for such labourious and toylesome workmanship for and during the term of seven years'. A significant part of the agreement was that all the profits would be divided into two equal halves at the end of each year. Woosey was to have one part and the innkeeper and his family were to have the other. All went well at first. The family proceeded to evict Anne Whalley, their tenant, from her home at Moor Street End, intending to convert it into a sugar refinery, but then there were many delays in making it ready for John. Eventually, the family decided in the meanwhile to ask John's father to allow his son to boil the sugar in his soap pan at Bickerstaffe. Once the family saw how easy it seemed to be to produce refined sugar, and realised how much money they would have to pay John, they insisted that Woosey should teach Henry Barton how to process sugar as part of their agreement. John and his father, who had financed John's apprenticeship in the sugar trade, objected. The family refused to pay for any more materials and John stopped work. They demanded their investment back and, as John had no means of repaying them, they put him into Lancaster gaol as a debtor.

The cottages that were originally the alehouse belonging to John Woosey's father, where sugar was refined by his son.

Earlier, in 1621, Roger, another member of the Barton family, had leased a house in Ormskirk with a cockpit from Thomas Hesketh.[6] The cockpit had been in the hands of John Goldborne, but he had died. Although the lease does not identify where the cockpit was situated, Cockpit Lane is shown between St Helen's Road and Chapel Street on later maps, so that was probably its original site. As it grew in popularity, cockfighting usually developed from being arranged outdoors on wasteland where spectators could gather around a slight hollow to watch the cocks, to being organised indoors where the sport could take place in all weathers. This cockpit was described as part of a new building, which suggests that cockfighting was well established in the town.

Another sport that was acceptable at that time was bear baiting; in fact, Ormskirk could boast its own bears and a bearward – a hereditary post that was held by the Whitestone family. As we have seen, the troublesome Whitestone family, John, Ralph, Richard, Godfrey and Joanna, often appeared before the Court Leet jury during the sixteenth century. The earliest mention of the bearward was in 1599, when Richard was accused of taking part in an affray in Leyland, and during the trial he was described as the bearward of Ormskirk. The family's bad behaviour continued into the seventeenth century, and in 1611 Thomas Whitestones, also

described as the bearward, was brought before the Quarter Sessions accused of harbouring 'at the time of Divine Service in his house the said Whitestones's sister, being a married woman with one Henry Laithwaite and in the night from eight of the clock until two in the morning'.[7] Then, in 1631, he was accused of striking John Leadbetter on the head with a pair of iron tongs and 'did break his head and the tongs likewise'.[8] Roger Barton, the owner of the cockpit, son of Thomas Whitestone's sister and William Barton, was also involved in the fight, during which he was stabbed with a bodkin and died of his wound two months later.

In 1622, Ralph Whitestones, another of the bearwards, died, and among his possessions was the bear named Chester, valued at £12.[9] The bear was taken over by Griffy (Godfrey) Whitestones, his grandson, who was attacked by one of his bears in 1637 and was forced to plead for help from the Quarter Session 'in regard of his great wounds and miseries, he being not able to go or to ride'.[10] Griffy died in November 1644, and the post of bearward in Ormskirk lapsed. Perhaps the injuries he had suffered, discouraged anyone else to take responsibility for the bears. Maybe Chester, too, had died or had to be destroyed.

Interestingly, in the nineteenth century there was a café on the site of today's Tesco called the Chester House Café, and it was thought that the name described its mock Tudor frontage, which resembled several on the Rows in Chester. However, according to a list of the property belonging to Lord Derby in 1653, Thomas Whitestones occupied a shop in that position on the south-western side of Church Street. It seems much more likely that the café was originally called Chester House Café because originally the house had been the home of Chester, the bear. It is unlikely that the people of Ormskirk would soon forget where the

An old photograph of Church Street in the nineteenth century, showing the Tudor style of frontage of Chester House Café on the left hand side.

celebrated bear and his keepers lived, and so his name had lived on until the late nineteenth century.

The only other recorded outdoor sport that the townsfolk enjoyed at this time was horse racing. Usually it was a sport enjoyed by the upper classes, who pitted their horses against those of other gentry, but sometimes it developed into a sports day for all classes. The *London Gazette* announcement in 1685, 'To all Gentlemen, that Ormskirk Plate in Lancashire ... is now put off ...', was aimed at the upper class riders, but then in 1696 a similar advert appeared, which included the lower classes, announcing that there would be a race for footmen for a tumbler valued £5 on the same course. On the following day, a smock valued at a guinea and a guinea in gold would be the prize for the winner of a race for women – not ladies. This suggests that the races were intended primarily for the household servants of the upper classes and it is doubtful whether the ordinary townspeople of Ormskirk would have been able to compete.[11]

All these happenings were insignificant compared with the events that were happening in the larger area and in the country as a whole. The mid-seventeenth century saw the English Civil War, which had a great impact on Lord Derby and his family. As he was the lord of the manor of Ormskirk, and his principal home was Lathom House, the people of Ormskirk were affected deeply by the war, especially when Lathom House was besieged by the Parliamentarians. At first, when the troops massed in and around the town, and townsmen prepared to join Lord Derby's troop, the innkeepers and traders saw the soldiers as potential customers, but soon they found that the influx of strangers brought many disadvantages. The troops were very poorly paid, if they were paid at all, and so they raided the gardens, farms and smallholdings of the town, and the townsfolk were left with little to eat. The men also brought diseases that spread around the district. The conditions continued to deteriorate until 1648, when a petition was presented to the Quarter Session, pleading for help after an outbreak of the plague hit the town. Among those who signed the petition were William Dun (the minister), Silvester Ashcroft, George Tipping, Richard Birchall (the schoolmaster), Thomas Wainwright, Emmanuel Morecroft, Richard Simkin, William Holland, Thomas Walton, John Heyes, Richard Duckenfield, Edward Breresm, Gilbert Ambrose and Richard and Thomas Moorcroft. According to the plea, 'some families (had been) sent unto cabins and others confined to their own houses' in an attempt to prevent the plague spreading.[12] The cabins were isolation huts where the sick were confined. It is significant that on a nineteenth-century map, the field between Wigan Road and Ruff Lane, where the old hospital was built, was called Cabin Hey. Evidently, that area of the town had been dedicated as a place for the care of the sick since the seventeenth century, and probably for many years before.

The petition continued, 'by reason of this contagion the markets and all manner of trading amongst us is interrupted and stopped', causing great poverty in the town. Indeed, it stated that about eight hundred people in the town would not 'be able to subsist without a speedy contribution (from) the country'. The plea ended

with the hope – or half-concealed threat – that if they received the money they would be able to keep the people within the 'town without doing any violence or prejudice to the county'. That threat influenced the court and money was sent to the town. However, in 1652 there was a plea that the receivers of the money 'detained' the contributions, leaving at least three hundred people in great distress. Even after that complaint, insufficient money was forthcoming to meet their needs, and consequently, in 1653, Miles Barton, the constable, William Grice, the churchwarden, and other leaders of the town were forced to plead once again for help from the Quarter Sessions, and after that the situation gradually improved.

While the plague was affecting the people of Ormskirk, Oliver Cromwell was made Lord Protector of the Commonwealth and the Puritan regime was established. In 1656, Nathaniel Heywood, a Puritan, was appointed to be vicar of the parish church. He leased a house in Chapel Street – now known as Chapel House – for £60 and extended it to cater for his family of six children. When Heywood was vicar of Ormskirk, Oliver Atherton, the leader of the Quakers based in Bickerstaffe, was active in promoting Quakerism. On two occasions he went to the parish church and spoke about his faith to the people who had gathered for the Anglican service. On the first occasion, he went into the pulpit before Heywood

Chapel House, the home of Nathaniel Heywood.

entered the church, and spoke to the congregation. When the vicar entered the church, the constables jumped up from their pew and took Atherton to the town hall, where he was imprisoned for the day. The next occasion, this time after the service, he tried to address the people from the pulpit, but two members of the congregation attacked him and 'pulled him by ye hair of his head and threw him out of the steeple house with much violence'.[13]

Several of the local Quakers refused to pay tithes to the Anglican Church, and so were arrested and brought before the Quarter Sessions. Oliver Atherton himself was committed to Lancaster gaol and imprisoned for debt. He believed that it was unjust for Quakers to be expected to pay tithes to an alien Church, so he refused adamantly to pay. His fellow Quakers appealed to the Countess of Derby, who was the lay rector and impropriator of the tithes of Ormskirk, to exempt him from payment, but she refused to make an exception to the rule. Consequently, he remained in gaol until his death in 1663, two and half years later. The Quakers put his body in a lead coffin and carried it back to Bickerstaffe, stopping at every marketplace on the way, including the one in the centre of Ormskirk. There they put the coffin on display and placed a notice on each market cross proclaiming: 'Here lies the body of Oliver Atherton of the parish of Ormskirk, who by the Countess of Derby had been persecuted to death for keeping a good conscience towards God in not paying tithes to her.'[14] There must have been an uproar in the town centre when that procession halted in Ormskirk.

When Charles II was restored, there was great relief among the inhabitants of Ormskirk, for they believed that they would at last be able to return to normal life. In fact, when William Grice, the parish clerk, announced the King's return at the market cross, he said that it was 'To the Joy of all Good Christians' and recorded his comment in the parish register for posterity. Soon afterwards, Lord Derby decided that it would be appropriate if a service of celebration was held at Ormskirk parish church, which he would attend with his retinue. His chaplain, Richard Sherlock, was dispatched to prepare for the service, and to his dismay found that the inside of the church had been very neglected and had been 'more frequented by dogs and swine than by men'.[15] This lack of respect for the actual church buildings had been evident for some time in Ormskirk as we have seen in 1588, when dung was laid against the church wall.

Maybe the interior of the church had also been vandalised by the Parliamentarians during the siege of Lathom House in the 1640s. This certainly happened in many of the churches in Cheshire when the Cromwellian troops were in that area. The Puritans despised any ornamentation in churches and removed statues or broke them up whenever they saw them. John Broxxop was the first Puritan to be appointed as vicar of Ormskirk by Lord Strange in 1628, and he was brought before the Consistory Court in Chester for refusing to wear a surplice in church, in accordance with his belief that there should be no decorations in the church and that included no vestments. In fact, many of the Puritans held services in people's homes instead of in the church.

All this was to change once the High Anglican bishops returned to power with the restoration of Charles II. They forced Charles to agree to the Act of Uniformity, which resulted in most Puritan vicars, including Nathaniel Heywood, being ejected from their positions. In his stead, Mr Ashworth, the headmaster of Merchant Taylors School in Crosby, was appointed vicar. Of course, Ashworth was unable to serve the town during the week, and so Heywood continued ministering to the townsfolk from his home in Chapel Street. He preached in the houses of local people, sometimes at one house at the beginning of the night, and then would 'cross the mosses by foot and preach towards morning to another company'. As Sir Henry Ashurst wrote in 1695, 'nor was he scant and short in his sermons but usually very long two hours at least often three … he forgot his own strength and his hearers patience. Yet he was beloved by all good and bad.'

This continued until 1672, when the Declaration of Indulgence allowed Dissenters to license premises for worship. Heywood licenced two chapels, one in Scarisbrick and the other in Bickerstaffe Hall, the home of Lady Elizabeth Stanley. When the Declaration was withdrawn shortly afterwards, he continued preaching in the chapels, and so warrants were issued for his arrest. The local officers were very reluctant to arrest him and every excuse was made to avoid any confrontation. Eventually, a deputy lieutenant sent soldiers to arrest him at Bickerstaffe. When Lady Elizabeth heard that they were approaching, she came down from her gallery and 'placed herself near the pulpit door hoping to overawe their spirits'. Nevertheless, as Heywood explained to his wife, 'I was pulled out of the pulpit with a pistol lifted up at my head a "God dam me" in my ears.' He was taken before the justices, but when they saw the amount of support he received from the gentry and the ordinary people of Ormskirk, they released him and allowed him to continue his work. In 1677, he died and a 'vast confluence of all sorts of people' gathered for the funeral service in the parish church. He was buried in the chancel, in the burial place of the Stanley family of Bickerstaffe.

Not all clergymen had served the people of Ormskirk so well in the seventeenth century. Batholomew Cade, who became the King's Preacher in Ormskirk in 1625, was summoned before the magistrates in Wigan in 1631 for the maintenance of the bastard child of Margaret Vaudrie of Ormskirk. She gave the court a vivid description of the night she had spent with the clergyman, drinking in Edmund Park's alehouse in Ormskirk, and then retiring to his chamber where the child was conceived. Cade protested his innocence, but his reputation was such that the magistrates found him guilty of fathering the child and ordered him to maintain her until she was twelve years old.[16]

One of the magistrates' chief concerns was licensing ale houses and making sure that they were in the hands of people who could maintain order. For instance, in 1684 Margery Hesketh, an 'impotent, lame' person, applied for a licence, but as she was unable to provide sureties, the magistrates, led by John Entwistle, refused to grant her one. Nevertheless, she continued to sell ale and beer and, because her ale house was in an 'obscure' place, 'bad company were harboured all the night

The east window given to the parish church in memory of Nathaniel Heywood by his descendents.

Bickerstaffe Hall.

The stone carved with the initials 'E. S.' (Elizabeth Stanley) at Bickerstaffe Hall.

in the jolly exercises of gaming and drinking'. The magistrates fined her twenty shillings, but the constable who was sent to collect the money or goods to that value returned, saying that all the goods in her house were not worth twenty shillings. The bench ordered that her alehouse should be suppressed as an example to others and to 'conduce the quiet of Ormskirk'.[17] As we have seen from the early 1500s until the beginning of the 1700s, it was very difficult to establish peace and quiet in Ormskirk.

Notes

1. L.A. WCW Roger Sankey, 1613.
2. Richard Pococke, *Travels through England 1754–1757*, Camden Society 196, p. 207.
3. National Archives DL 1/232 RC 6923.
4. Cheshire C.R.O. EDC5 (1677) No. 9.
5. National Archives PL6/34/37, PL10/103.
6. L.A. DDHE 28/47.
7. L.A. QSB 1/90/40.
8. L.A. QSB 90/1/39.
9. L.A. Ralph Whitestones 1622.
10. L.A. QSB 1/194/62.
11. *London Gazette*, 1696.
12. L.A. QSP 3/2/, July 1648.
13. L.A. FRL 1/A.
14. G. Couthard newstead, *Gleanings towards the Annals of Aughton*, pp. 15–16.
15. Thomas Wilson, *The Life of Dr. Richard Sherlock*, 1713.
16. I am indebted to Dr Alan Crosbie for drawing my attention to this.
17. L.A. QSP 590/23.

Chapter Three

The Effects of the Jacobite Rebellion on Life in Ormskirk

The justices at the Quarter Sessions dealt with several cases in the early eighteenth century which potentially could have disturbed the peace of the township. One of the earliest was in 1705, when the local shoemakers, united in what could almost be seen as an early trade union, approached the Quarter Sessions on behalf of a fellow worker, Thomas Croxton. Evidently, the making of shoes was subdivided into those who made the heels and those who made the uppers and soles. Croxton was a heelmaker who supplied heels to many of the local shoemakers. However, at this time the navy needed more recruits and pressgangs were sent out to compel men by whatever means that was necessary to enrol. One of these gangs, led by a Captain Arnold, had caught Thomas and had forced him to join the navy. Whether he was caught in Ormskirk or elsewhere is not stated, but the effect of his disappearance had dire results on the other local shoemakers, who decided to protest. Several of them claimed that that they did not know how to carry on their trade without the heelmaker. As shoemaking was one of the most important trades in Ormskirk, there were many workers who united to bring the case to court; among them were Thomas Hodson, Thomas Frith, Samuel Dunbabin, Landell Barnes, William Croft, Richard Rawlinson, Johanah Jonson and John Danell. The justices deferred their decision until the following day and unfortunately there is no record of those proceedings, so we do not know the result of their protest. It is doubtful whether they would be able to secure Croxton's release, but evidently the shoemakers felt that by banding together and protesting, they had a chance of succeeding.[1]

Other groups of the townsfolk were worried by events following the Glorious Revolution, when James II was replaced by William II and Mary. James, a Catholic, had favoured those of his own faith, even going so far as disgracing the Protestant justices, including John Entwistle of Ormskirk, and replacing them

with justices who followed the Catholic faith. At the local level this inflamed the religious divide, especially when the coming of the Protestant monarchs reversed the trend and restored the prominence of those of the Anglican faith. One example of the underlying unrest occurred in Scarisbrick in 1692, when Alice Farrar and her mother were rippling flax in a barn in Scarisbrick with Kadough Farrell, an Irishman, who said, 'Hemp will be very dear you have all hemp enough but before Michaelmas day my master King James will be in England again and you must all be hanged at your own doors.'[2] As many Irishmen, probably holding similar opinions, came over to work in the fields during the summer months, such sentiments troubled the Protestant townsfolk, especially when support for the Jacobite cause gradually grew among the Catholic townsfolk. Consequently, the authorities decided to search the houses of those who were suspected of supporting the cause. If any evidence of Jacobite activities was found, those guilty of taking part were imprisoned. In the Ormskirk area, eighteen people altogether were convicted and confined as 'prisoners of the Crown' in Ormskirk prison.[3]

There is currently a debate as to where that prison was located. However, as the Quarter Sessions took place in the old town hall in Church Street, it is likely that the prison was near that building. Indeed, as we have seen when Oliver Atherton attempted to preach in the parish church, he was taken by the constables to the town hall, where he was imprisoned for the day. In 1773, the prison was rebuilt and that suggests the prison was part of the town hall complex, which was rebuilt in the 1770s. Some records refer to it as the 'round house' and in fact a very stout, curved stone wall still exists behind the old town hall in Church Street, dividing the back of the property from the back of other properties in Burscough Street. Was that the wall of Ormskirk prison? It is certainly a much stronger wall than would be needed to define a boundary.

After the defeat of the Old Pretender in 1715 at the battle of Preston, the Jacobites in the district retreated into obscurity, and yet vestiges of the Jacobite movement could still be found in the town. For instance, among the goods of William Grice, which were valued after his death in 1725, was a copy of *Eikon Basilike*, a book that described Charles I's idea of kingship and was essential reading for all Jacobites.

When the Young Pretender, Bonny Prince Charlie, began his campaign in 1745, the majority of the townsfolk of Ormskirk did not support his cause. The Earl of Derby's regiment, including many Ormskirk men, marched into Liverpool in support of the King, while Sir Henry Houghton's regiment of Royalists moved into Ormskirk. Sir Henry voiced his anxiety when he wrote on 22 November, 'We are in the greatest distress here upon the approach of the rebels and the King's army at too great a distance to afford us any relief.'[4] No doubt Sir Henry's anxiety would be communicated to the townsfolk as they waited to see the outcome of the campaign, dreading a repeat of the experiences of the previous generation during the Civil War. Nevertheless, there were still some in the area who wanted to support the Prince's campaign. In fact, the *Gentlemen's Magazine* of Saturday

This may have been the external wall of Ormskirk prison, behind the old town hall. Recently it has been altered and rendered.

30 November reported that on the previous Monday night, two hundred disorderly persons proclaimed the Pretender King in Ormskirk, and beat a drum appealing for volunteers for his service, but the townsmen rose, fought them, took ten or twelve prisoners and then dispersed the rest. This suggests that the 'disorderly' people were not Ormskirk townsfolk, but strangers who had come into the town to recruit support for the Pretender. However, there must have been some who would have welcomed a Catholic king.

When the rebels decided to retreat from Derby in December 1745, discipline among the Jacobite troops broke down, and they began looting and behaving like a 'band of raiding pirates' as they went through the towns and villages on their way back to Scotland.[5] There was a skirmish in Liverpool involving some of the Highlanders, and as they passed through Ormskirk, some of the rebels went into the glasshouses and took a great quantity of bottles, which they broke into pieces and scattered behind them on their retreat to delay any troops – especially those on horseback – who might be following them.[6]

The townsfolk of Ormskirk were incensed at their behaviour, their lack of discipline and the troubles they caused. Unfortunately, many of the local Protestants looked upon all Catholics as supporters of the Jacobite cause, and vented their anger on the local Catholic leader, the priest, Father Maurice Bulmer. Taking their cue from the Protestants of Liverpool, who rioted in favour of the Protestant succession, they too rioted and attacked the house of the priest, destroying his furniture and his library. The chapel in the priest's home, the Mass House, was desecrated and all the contents of the chapel and his house were burnt. Fortunately he escaped, and at least one precious Latin manuscript was snatched from the flames by his supporters.[7]

It is unclear where the priest's house was situated, but it is known that when he came from Croxteth Hall in 1735, Bulmer bought Entwistle's house. If that house was the one that originally belonged to the Laithwaite family, it was on the corner of Aughton Street and Moor Street. Perhaps one day archaeologists will unearth the remains of a fire under that building – or indeed the glass bottles strewn by the fleeing Highlanders – and confirm where these events took place. It is certain that Father Bulmer moved out of the centre of Ormskirk and built a house over the border in Aughton, on the site of today's St Anne's Catholic social centre.

This was not the end of the Jacobite rebellion as far as Ormskirk was concerned, for there were still some who hoped for a return of the Stuart dynasty. In fact, John Halton of Melling was accused at the Quarter Sessions in 1746 of drinking the Pretender's health, saying, 'By the name of Prince Charles', and calling him the son of King James. The court reacted immediately and decreed that he should be stripped naked to the waist, tied to the Rogues' Post in Ormskirk and severely whipped.[8] Afterwards he was to be discharged, but his punishment would be a public warning to all who had similar loyalties to the Jacobite cause. The whipping post was in Burscough Street, near the centre of the town, where all the inhabitants could gather and watch the proceedings. The other possible means of punishment

The possible site of the old Mass House.

An old print of the Mass House.

– the ducking stool – was at the bottom of Aughton Street, where the brook flowed under a bridge, giving the bystanders a good vantage point from where they could watch the punishment being administered.

During the second half of the eighteenth century, the brook and the bridge over it were the scenes of some strange happenings. In 1755, James Stuart was presented to the Court Leet for laying 'slutch' on the bridge 'to obstruct the same', and was fined 5s 'for every week the same (should) lye there'. Then the following year he rented the mud hole for two years from Lord Derby for £1 2s 6d. Four years later, Mr Ashurst paid rent for the mud hole, and in 1771 he was joined by Mr Nicholson, who paid £4 4s 0d for it. Although there is no mention of what they used the mud hole for, it is likely that they were providing mud baths for their patients. During the 1700s spas, mud baths and various strange cures increased in popularity. All kinds of cures and medicines were sold on the Ormskirk market; in fact one quack, Thomas Proxton, known as Mad Roger, attended the market until a few years before his death at the age of 108 – a good recommendation for his remedies.

In the 1790s, one of the relatives of Dr Miles Barton, who paid £1 for taking water – or mud – from the same stream, was the subject of an anecdote recorded by Nicholas Blundell earlier in the century. He wrote:

The brook at the bottom of Aughton Street, the site of the ducking stool.

Pothecary Barton built a summer house and ere it was finished he had a mind to go to the top of it; his workmen persuaded him to the contrary saying it would be dangerous for him lest he should fall; he answered he would take care of himself; but he built it with that intent that someone might fall and hurt themselves that he might get money by curing them; the pothecary did go to the top of his summer house and fell down and got such a fall that it put him into a distemper of which he died.

Two local doctors are famous countrywide for their achievements during the eighteenth century. One was William Moorcroft, the illegitimate son of Ann Moorcroft, who was baptised in 1767, and was brought up in Ormskirk by his grandparents. He trained as a surgeon in Liverpool and was apprenticed to a Liverpool surgeon, John Lyon, to train as a physician for five years. However, after helping with an outbreak of cattle plague during his fourth year, he decided to abandon his apprenticeship and train in animal medicine, which involved moving to Lyons in France to study. After qualifying in 1780, he moved to London as England's first qualified veterinary surgeon, and built up a very successful equine practice, which attracted wealthy clients, including the royal family. He also ran a breeding stud for the East India Company in Romford, and by 1794 he had become the teaching professor at the new veterinary college in Camden Town. When he received a proposal from the East India Company that he should go to India to organise the breeding of cavalry horses in Bengal, he could not resist the temptation to travel abroad. He spent several years journeying into Afghanistan and Tibet, ostensibly to find improved breeding stock, but actually exploring those areas, making commercial and political contacts and doing important botanical and geographical research. During his work he had many close encounters with hostile, native people, and, unfortunately, he disappeared while on an expedition to Bokhara in 1825.

Another Ormskirk man who achieved fame in a distant land was William Gould, who worked for several years in Russia. When he was a young man, Gould was employed by Richard Wilbraham-Bootle as a gardener at Lathom House. There he came to the notice of Capability Brown, who recommended him to Prince Potemkin of Russia, a close friend of Catherine the Great. The Prince commissioned him to landscape the gardens of the Taurida Palace in St Petersburg, and during the next thirty years he designed several other gardens in Russia and the Ukraine. He returned home in 1806, died in 1812 and was buried in Ormskirk.

The other famous doctor who was brought up in Ormskirk was Joseph Brandreth, who was baptised in Upholland in 1745 and was the son of the tanner Thomas Brandreth. The family moved to Ormskirk at some date between 1745 and 1747, and by 1752 they had settled in Burscough Street. Joseph studied medicine at Edinburgh University, and returned home to practise in Ormskirk from 1770 until 1776, when he was appointed as physician to the Liverpool dispensary. In 1780, he became a member of the staff at Liverpool Infirmary, but continued to work for

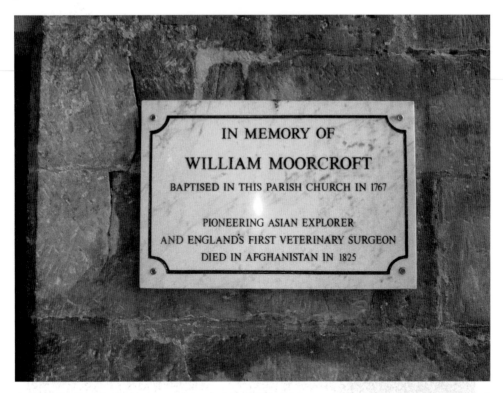

IN MEMORY OF

WILLIAM MOORCROFT

BAPTISED IN THIS PARISH CHURCH IN 1767

PIONEERING ASIAN EXPLORER
AND ENGLAND'S FIRST VETERINARY SURGEON
DIED IN AFGHANISTAN IN 1825

A plaque in Ormskirk church commemorating William Moorcroft. A similar plaque was placed near Littlewoods store in Oxford Street, where he practised towards the end of the eighteenth century.

the less fortunate people of Ormskirk. During his time at Liverpool dispensary, he had realised how much benefit the poorer people received by being able to consult a doctor and obtain medicine without having to pay a high fee. Consequently, he suggested founding a similar organisation on a much smaller scale in Ormskirk. He collected funds for the charity, rented a small house in Butcher's Row on Lydiate Lane (a site opposite the new police station in Derby Street) for £5 p.a., and in 1797 the new dispensary was opened. Lord Derby gave an annual subscription of £2 2s and several local people also supported the project regularly. An apothecary was appointed at a salary of £7 p.a. and the cost of heating the surgery was met by the charity. When Joseph Brandreth died in 1815, his wife Catherine and son Joseph Pilkington Brandreth, also a well-known doctor, continued to support the charity.[9] It is interesting that Catherine's mother later married Miles Barton, the surgeon who paid for the 'liberty of taking water for a mud hole'.

The dispensary was a wonderful asset to the people of Ormskirk who could go for advice and collect medicines, but for those who were too sick or disabled to attend the dispensary, the only alternative was to go into the workhouse. That had been founded in 1726, when the overseers of the poor of Ormskirk bought a

Joseph Brandreth.

The gravestone commemorating Joseph Brandreth and his wife Catherine in the graveyard of the parish church.

house that had belonged to Henry Valentine in Aughton Street. There they planned to care for the local townsfolk and also for those from Lathom, Bickerstaffe and Burscough who were desperately poor and had no relatives to help them. Great emphasis was put on work and the regime was intentionally very harsh so that no-one would take advantage of the system. The project was so successful that by 1732 other outlying townships had joined the scheme and the centre was moved into bigger premises in Moor Street. It was housed in three converted cottages (opposite the present bus station) and accepted the needy poor from twenty-two townships, ranging from Walton to Mawdesley. Although the workhouse master, who was appointed in 1765, moved into an 'ancient stone mansion' on the corner of Moor Street and Chapel Street, conditions inside the workhouse must have been very overcrowded throughout the century. The residents were segregated into male and female wards, the food was very basic, mainly porridge, broth, cheese and milk, with meat only on offer three times a week, and the residents were expected to work extremely hard for their keep on that sparse diet.

Although he supported his son in founding the dispensary, Joseph Brandreth's father, Thomas, continued trading as a tanner in Burscough Street, where he employed many local men. He also had a shop in Church Street, where he erected

Derby Street, the site of the first dispensary in Ormskirk.

a weighing machine in 1792, thus allowing the public to check the weight of the leather he sold. At the site of his tannery behind the Brandreth House, there are still signs of deposits from the tanks where the fleeces and skins were soaked and the tanning process took place using tannin from the bark of oak trees bought from Lord Derby's estate. Brandreth kept several large dogs to remove any meat that had been left on the underside of the skins, and one of these dogs escaped from the tannery in 1798 and terrified the townsfolk. As a result, Brandreth was brought before the Quarter Sessions and fined for keeping a dog that was a danger to the public.

As one of the leading tanners in the town, Thomas was appointed to serve as the searcher and sealer of leather and to present any tanner who tried to sell leather that was not properly tanned, to the Court Leet. Although he had never been presented for this first offence, he was presented to the court on two other occasions: once for refusing to attend the swearing in of officials, and a second time when it was recommended that the steward should discharge him as the foreman of the jury for 'neglect of duty and incivility of conduct'. Later the tannery business was carried on by his son, also called Thomas Brandreth, who, according to depositions given at the duchy court during a case concerning the tolls of the market, was a very

The Moor Street workhouse building.

The site of the tanning pits behind the Brandreth House, showing the deposit left by the tanning process on the garden wall.

wealthy man by 1797.[10] He owned five houses in Burscough Street: his own home, his mother's home and others occupied by various tenants, including Mr Howard, Mr Holland and Mr Rawlinson, and six houses in the other three main streets of the town, which were tenanted by Peter Berry, Richard Brighouse, Cuthbert Nixon, Thomas Wood, Jonathon Rogers, William Blundell and Thomas Tinsley.

The evidence given at the duchy court in 1797 also highlights that there were at least three mills in Ormskirk. There was a horse mill in Church Street, a wooden mill on Greetby Hill and a windmill on the Knoll. The horse mill was used to grind malt and alongside it was a malt kiln, occupied at that time by William Ousey. John Chadwick was the tenant of 'Greepy' mill, which had been built by his grandfather on the site of an old mill that had stood on the site for as long as those giving evidence could remember. The windmill on the Knoll had been built in the 1790s by Thomas Sutch, but unfortunately it is unclear exactly where that was. It is possible that it was on Ormskirk moss, or possibly near Mill Street, which must have been the site of a mill at some time in the past. The rentals of 1775 list an old-established horse mill known as Finches Mill in Aughton Street, which had been tenanted by Gilbert Balshaw in the 1650s, and had passed by then to James Culshaw.

The millers, the tanners and many of the craftsmen of Ormskirk had apprentices who worked with them to learn their trades. Usually apprentices were tied for seven years to serve their masters for very little, if any, wages. They lived with their masters and were subject to very strict rules. In 1707 Robert Gregory, who was apprenticed to Henry Helsby, the Ormskirk glazier, could bear the harsh discipline no longer. After putting up with the treatment he received from his 'strict and severe' master for four years, Robert left his employment. Henry Helsby was furious, and found a ship's master in Liverpool who would take Robert and pay Henry compensation to cover the cost of providing labour for the remainder of Robert's apprenticeship. The master intended to take Robert to Virginia to work as a slave in the tobacco fields. When Robert's father, James Gregory, heard what was planned, he could not allow it to happen. He appealed to the Quarter Sessions to intervene and save his son. The court ordered that Robert should return to his late master and serve him for the remaining years of his apprenticeship.[11]

The Helsby family were the most important glaziers in the town, but it is unclear whether it was Henry's shop that was broken into by the fleeing Jacobites. However, when they were considering rebuilding the parish church in 1724, the church authorities asked John Helsby to provide an estimate for all the glazing that was planned. He replied by giving an estimate of £67 for glazing the windows, which included renewing all the lead around the glass. Various other local craftsmen, including plasterer Robert Gill, slater William Davie, nailer Nathaniel France, masons Robert Halton and George Bate, blacksmiths John Rigby and Richard Halsall, and carpenters John Atkinson and Richard Smith, also submitted their estimates for the restoration of the church, which including re-roofing the whole structure.

The townsfolk had appealed to the Lord Chancellor, the Earl of Macclesfield, for help, claiming that their church was a large, ancient structure and, despite them having laid out great sums of money for repairs, it was so ruinous that it could not be repaired. It needed completely rebuilding. It is certain that the building was in a sorry state; the north pillar was already 23 inches out of square and the south pillars were 14 inches out. One beam of the 'roof moved so much one Lord's day in the morning when the congregation was at Divine Service that they were terribly affrighted and were forced to have the same that day propped and leaned on during the service'. The magistrates claimed that the inhabitants of the town were very poor and could not afford to rebuild their church; in fact, they would shortly 'be destitute of a Church'. They had all been too optimistic to hope that they would be given enough money to completely rebuild the church, but some money must have been made available, for major repairs were done to the structure.[12]

At a later date, galleries were erected around the church; this may have been done because at that time the Anglican authorities were very concerned about the growth in the population and the lack of accommodation in their churches. They also realised that the new chapels being opened by the Dissenters were providing much-needed accommodation, and so attracting many people to worship in them. It is certain that the number of Dissenters in Ormskirk was increasing, and several members of the Heywood family had applied for licences to hold meetings in various places. For instance, Mary Heywood applied for a licence in 1709 for a meeting house in Aughton Street, on the site of Morrisons supermarket, where a gravestone in the pavement commemorates the family of Reverend Fogg, who was the minister of that chapel during the nineteenth century.

Later in the century a complete rebuilding programme was authorised, this time by Lord Derby, who agreed to the rebuilding of the town hall complex in Church Street. It was to include a public house, the market house and two shops, one belonging to the Crosby family, who were Quakers. It would seem that the project was well overdue, for Jane Crosby had pleaded with the steward to beg his Lordship to agree to 'make this house more convenient for since my neighbour Plumbe built so very high opposite us it has caused ours to smoke to such a degree although I have been at a pritty great expense I don't know how to live in it over winter'. Again, local craftsmen were employed; John and Henry Walsh were the bricksetters, Thomas Smith was to do the blacksmith's work, John Muschamp was to be the leading mason, while other local people supplied materials. Thomas Brandreth supplied both leather and hair from the tannery for the plasterwork, Henry Shepherd supplied a wheelbarrow and Mr Hamner of the Wheatsheaf supplied the all-important ale for the workers. The Earl also called on his tenants to 'perform boons and services of carting and labouring'. It is unclear whether that meant that several tenants had promised in their tenancy agreements to do such work without payment, or whether they were to be paid by the Earl.

The site had to be cleared and, while the work was in process, the butchers had to move out of the shambles into the open streets. It was a popular move, for when

The gravestone commemorating the Fogg family.

the work was completed the butchers were reluctant to leave their new positions. Consequently, in October 1781 the Court Leet issued the following order:

> Whereas the Rt. Hon. The Earl of Derby has at considerable expense erected and built a shambles in the most commodious part of the town and near its centre (And it is not doubted by the Jury that the same will be let at a fair price) that the present situation of the butchers is a nuisance to the town in general. It is therefore ordered by this court that so early as the said shambles are properly finished for the reception of the butchers that they do remove their standings or stalls out of the public streets under the penalty of 39s 6d to be paid to the Lord of the Manor. And it is further ordered by the court that all country people and others that bring meat at Christmas or any other season of the year stand in the said shambles or do place their standings or stalls in the open part of Aughton Street next below Mr John Clark's house and nowhere else under the like penalty of 39s 6d.

It is significant that the jury of townsfolk had not missed the opportunity to stress that they expected the rents to be set at a reasonable level, while the steward had fixed a very high fine to persuade the butchers to obey the order. That was a vain hope, for a year later a group of butchers, including James Berry, John Tatlock, Jonathon Rogers, James Moorcroft, William Nelson, John Fell James Walmesley, Mr Richard Taylor, Mr John Clark, William Croft and John Rimmer, were brought before the court and accused of fixing their stalls in different parts of the marketplace, and were to be fined 39s 6d. However, two months later on 27 December, the townsfolk, represented by the affearers, the officials who reviewed fines, reduced the fines to 6s 8d each.

The house of Mr Clark was also selected to be the place where the bellman, the town crier, was to shout his messages to the townsfolk, and they were to pay him four pence each time he called. Although we do not know what the subject of these messages was, whether it would be the approach of rebels, the whipping of a criminal, the opening and closing of the market, or a call for help in the case of a fire, or perhaps all of these, we do know exactly where he was to call. The court selected the following sites: in Moor Street – at the toll bars, at Mr Sephton's and in the marketplace; in Burscough Street – outside Mr Wood's, the Wheatsheaf, Mr Segar's, Mrs Coupland's and Thomas Harford's; in Church Street – outside the vicarage, Mr Gill's, Mr Plumbe's and Mr Smith's; and in Aughton Street – by the fish stones, Mr Clark's, Mr Bold's, the Dissenter's chapel, and the house of Thomas Chadwick.

The Court Leet also issued orders intended to keep the town clean and free from roaming animals. The pinfold was set up on the site of Victoria Park, where all the stray animals could be collected and kept until their owners could collect them. When pigs escaped, they usually grubbed up the roadways and caused endless trouble in the marketplace. Consequently, in 1754 the court appointed Henry

Today's bell man or town crier.

The site of the shambles today. The entrance marked by the white door led into a narrow lane, the shambles.

Moorcroft to look for straying pigs, put them in the pinfold and then inform the Court Leet so that the owners could be fined. For that service he was to be paid ten shillings a year.

There was also a great deal of concern about the amount of dung that was left on the streets and walkways by the horses and other pack animals that were brought into the town. Consequently a year later, William Moorcroft was appointed to be what was described as the scavenger for Ormskirk township. Each morning he was to collect and carry away all the dung that was left on the public roads and walkways. He too was to be paid ten shillings a year by the constable and, as part of his salary, he could have the dung for his own use, possibly to sell as fertiliser in the market. Townsfolk were expected to keep the causeway in front of their own houses clean and were fined for not doing so. The court also attempted to keep the shambles clean and as attractive as possible, despite it being the place where animals were slaughtered. For instance Samuel Heys, one of the butchers, was fined for leaving a cask containing blood and 'other dirt' standing at the end of the passage. Of course, some people still regarded the roadway as a dump for their rubbish; in fact, in 1790 both Fanny Robinson and Ann Gregory were fined 2s 6d for repeatedly laying dung in the street, despite being asked to stop doing it.

Victoria Park today, the site of the pinfold.

In a similar case, John Clark, the ropemaker, was accused of sinking a midden – a dump for rubbish of all kinds – in the street at the front of his house in Aughton Street. No wonder he was fined the large sum of £1 19s 11d.

The safety of the townsfolk was also a major concern for the Court Leet and fire was a very real threat when houses were built so close to one another. Despite the fact that many of the small cottages with thatched roofs had been replaced by brick houses, the Court Leet decided in 1789 that the danger from fire was sufficient to appoint four people – Abraham Allen, John Allerton, George Hesketh and Robert Ormesher – to act as the town's engineers. That meant that they were to be in charge of the town's fire engine, which was little more than a tank on wheels with a pump and hoses. The townsfolk seemed unaware of the danger of fire, for the following year the court found it necessary to make another order that anyone who set fire to their chimney, would be fined. Despite all the court's efforts, even the engineers themselves were not convinced of the real danger or the importance of their task. In fact, in 1790, the court had to fine George Hesketh, one of their new engineers, 7s 6d for refusing to assist at the fire at Mr Thomas Woods' property.

As the townscape was gradually transformed, other dangers emerged and various townsfolk were presented to the court for negligence and lack of consideration for

other members of the community. Fine houses were built along the main streets, and several of these had cellars where coal or other commodities could be stored. However, these cellars had openings on to the street and several people, including the schoolmaster, the Revd William Naylor, were fined for leaving their cellars uncovered.

Rainwater cascading from the roofs of these houses onto passersby was another offence that came before the court. A group of townsmen, including Miles Barton, the surgeon, of Moor Street, Henry Gill, who had a tenant, Agnes Woods, in the house he owned in Burscough Street, John Pye of Church Street, and Miss Hewitt of Moor Street, were all fined for neglecting their gutters in 1784. Perhaps the most bizarre offence was committed by the widow Ann Shaw, who was accused of not having a door on her outside privy and dunghill to screen them from public view.

A group of craftsmen in Ormskirk supplied the elegant Georgian houses throughout the country with amazing clocks. For many years the local clockmakers had constructed, mended and serviced the clocks in various churches and town halls, and Ormskirk watchmakers had been famous for their craftsmanship since the 1600s. However, it was with the coming of the Georgian era that they produced their masterpieces, many of which are highly prized today. Among the Ormskirk clockmakers was John Taylor, who was working in 1723, Thomas Atkinson in 1767, Thomas Helm in the 1760s and John Wignall in the 1790s. Some of the earliest domestic clocks, known as lantern clocks because of their shape, were made by Henry Webster of Aughton and J. Barton of Ormskirk, who were among the first clockmakers to make them in seventeenth-century Lancashire. Thereafter, as the demand grew, the clockmakers produced increasingly complex timepieces. An outstanding example is the astronomical clock with two side panels that was made by Thomas Barry in 1787. When it came for sale in 2002, it was bought for £250,000 by the National Museums and Galleries on Merseyside with contributions from the heritage lottery fund and the National Art Collections fund. It has an eight-day movement and above the front face is an ornamental dial, which tells the time and age of the moon, with the sun rising and setting above a painted landscape. Above the left-hand face is a painted dial showing the day of the month on a perpetual calendar, while above the right-hand panel the planets and the moon revolve around the sun. It strikes on the hour and plays three tunes twice a day with a special tune on Sunday, a truly remarkable timepiece.

James Moorcroft, a local cabinet maker, made the astronomical clock's mahogany case topped with a pineapple finial, and yet another group of craftsmen made the unique Ormskirk chairs which were produced in the town until the nineteenth century. One of these later chair makers was Richard Orme of Wigan Road, who died in 1854. Valuable examples of the work of these craftsmen can be found occasionally in local antique shops.

A new concern for public health emerged towards the end of the eighteenth century, and judging by a couple of cases that came before the Court Leet, the

The astronomical clock made by Thomas Barry in 1787.

concern was certainly justified. One of these occurred in 1790 when James Ormesher of Lathom was fined for making a hole on his premises, filling it with dung and allowing the water from this manure heap to drain into a well used by the public 'to the injury of the water and his neighbours'. In a similar case six years later, James Riddiough was fined because the water from his privy seeped through the foundations into James Walmesley's back kitchen. The court also needed to keep a very close watch out for contaminated or unhealthy foodstuffs being sold in the market. For instance, one fishmonger, Michael Brookfield, from North Meols, was fined for selling stinking fish to James Atherton from Pemberton, a case that incidentally shows how far people travelled to Ormskirk market in the eighteenth century.

Meanwhile, the same old offences were taking place in the market. Andrew Goore of Aughton and Thomas Johnson sold potatoes underweight; similarly, Richard Cuquit of Lathom sold butter 'short of weight' and William Lunn of Longton sold beans a whole quart less than stated. Some stallholders, for example Martha Pye, used weights that did not conform to the correct standard, while others bought or sold produce before the market bell had signalled the start of trading. In 1794, one customer, John Wright, was accused of buying a whole cartload of mussels before the bell, probably in the hope that they would not deteriorate before he had time to sell them on to his own customers.

Gradually, the Court Leet seemed to be losing its power. People were defying its orders and refusing to obey its officials. Thomas Johnson refused to surrender his measure to the clerk of the market and even John Rutter, the landlord of the Wheatsheaf, the most prestigious inn in the town, refused to allow the ale tasters to test his ale. Both of them were fined, but there seemed to be a growing contempt shown towards the court as officials refused to serve, and others did not appear at court to be sworn into their respective offices.

Another sign of things to come was the appearance of factories in the town. One belonged to a fustian manufacturer, William Green of Westhoughton, who came to Ormskirk in the late 1700s. This factory may well have originated as a collecting base for the bolts of cloth woven by the handloom weavers of the town; on the map of Ormskirk drawn in 1851, a collection of buildings surrounding a yard on the site of Derby Street West was still called the cloth hall. Although its name did not change, it became a place where cloth was woven, and in 1780 Thomas Wright, a poor boy from North Meols, was apprenticed by the churchwardens and overseers of the poor to work in the factory and learn the skills of a cotton weaver. However, a survey conducted in 1787 listed a cotton manufactory leased to Plumbe and Woods. Without more evidence, it is unclear whether this was the same factory leased to different tenants or another building altogether.

George Davenport from Wigan leased another factory in the town from Lord Derby in 1790. It is likely that this factory was not used for weaving cloth but for spinning silk thread, which was then distributed around the town to be woven by townsfolk in their own homes. Silk ribbon had been woven in the town since the

early years of the century; in fact, the inventory of William Hewitt taken in 1723 listed silk 'in the knot' worth 10s and 'ribband in the looms' worth 3s. Handloom weaving of silk continued to be one of the chief occupations in the town, and as late as the nineteenth century, Ormskirk people were weaving silk in their own homes.

By 1795, Davenport wanted to update his factory because more intricate machinery was available. He approached the steward for the Derby estates and it was agreed that Lord Derby would spend £1 on lead, 10s 6d on twenty-one lights and 5s 10d on putty for work done on the factory. This suggests that large windows were put into the building so that workers could see to operate the powered spindles. Lord Derby must have decided that it was money well spent, for he later increased the rent for the factory from £26 to £32 a year. On the 1851 map, the old silk factory is shown on the site of the houses behind the present library on Derby Street West, and terraces of cottages are shown along a narrow lane called The Walk which ran between the factory and Hants Lane. These were the homes of the workers and were demolished early in the twentieth century. The Industrial Revolution, with all its advantages and disadvantages, had arrived in Ormskirk.

Cottages that housed the workers in the silk factory.

Notes

1. L.A.QSP 968/2.
2. L.A.QSP 723/27.
3. The names of those prisoners were Richard Noble, Richard Battersby, Thomas Kay, James Gardner, James Kay, Myles Gregory, James Barton, John Brown, John Trapps, John Kay, George Atkinson, William Sutcliffe, Henry Dumbell, Jeffrey Smith, Robert Rylands, Richard Ellis, William Richardson, George Deys.
4. Bagley, J. J., *Lancashire Diarists, Sir Henry Houghton*, p. 140.
5. McLaren, Morag, *Bonnie Prince Charlie Panther 1872*, p. 128.
6. *St James Evening Post* of 12–14 December. For glasshouses see later in this chapter.
7. Palatine Notebook 1881 Vol. 1. p. 87.
8. L.A. QSO 2/115.
9. L.A. DDK 1981. In 1810, the secretary of the charity was Mr Houghton.
10. L.A. DDK 258/1.
11. L.A. QSP 968.
12. L.A.QSP 1226.

Chapter Four

The Townsfolk in the 1800s

Despite the development of the two factories, Ormskirk did not become an industrial town and comparatively few Ormskirk people became factory workers. Admittedly, some did work in either the cloth hall or the silk factory, but the majority of the townsfolk maintained their traditional links with the market and with servicing the town's large agricultural hinterland in various ways. The cloth hall was in the hands of Richard Latham in 1825, and it continued to be used for the manufacture of fustian, a course cloth of cotton mixed with flax. It was recorded that fifty-eight workers were employed in the cotton factory in 1839, but it is doubtful whether they all worked in the Burscough Street factory, for in 1825 John Woods was described as a linen and cotton manufacturer of Moor Street. Was this yet another factory? Or was that his home and did he work in the Burscough Street mill? So many questions cannot be answered without further evidence. According to an advert in the *Manchester Mercury* for 8 May 1810, one attempt was made to increase the foothold of the cotton industry in the town. The large factory in Burscough Street was vacant and apparently the Derby estate hoped that its future was to be as a cotton spinning mill, for the advert specified that the factory was four storeys high and was 'very well calculated for throstle spinning', a throstle being a spinning machine for wool or cotton. The size of the building suggests that the advert refers to the silk factory, but that building never became a cotton factory.

The silk mill and its outworkers thrived during the early years of the century; in fact, by the 1840s 200 people were involved in the manufacture of silk, and during the next ten years that increased to 330.[1] Most of these worked on handlooms in their own homes, but the silk mill continued to supply the thread until the 1850s. Then the factory was forced to close and the diminishing workforce had to obtain their silk

The town centre in the nineteenth century.

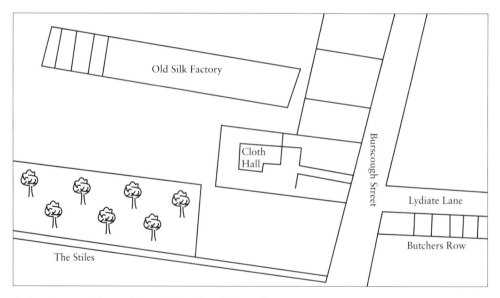

A sketch map of the position of the silk mill from the 1851 map.

thread from other sources. Nevertheless, even in 1861 the census listed several silk weavers in the town: in Hants Lane there were seven, including the Reynolds family – John aged seventy-four, his wife Agnes aged seventy-three, his son Bartholomew and daughter Ann – and in Martin Square off Hants Lane there were nine, a few of whom were members of the Wright family. The handloom weavers steadily declined in number, and in 1976 I was told that Miss Martin, an elderly resident of the town, remembered her father taking her when she was a child to visit a cottage in Chapel Street to watch silk ribbons being woven on a handloom in an upper room. She commented that she felt very ashamed when her father only gave the weaver a pound of tea as a reward for allowing them to see him at work. At the time, Miss Martin was told that he was the last handloom weaver left in Ormskirk. It is very likely that he was the handloom silk weaver listed in the 1901 census: Daniel Johnson, aged sixty-nine, who lived in the third house in court number seven off Chapel Street.

There was an attempt in the 1870s to establish another cotton factory in the town, but this also failed. The first meeting of the provisional committee of the Ormskirk Spinning and Manufacturing Company was held in March 1876 at the offices of Brighouse & Brighouse, and it was decided to register the company with a capital of £50,000 in 10,000 £5 shares. The local directors were Thomas Alty, a tea merchant, John Martin, a gas engineer, and James Blundell, a cotton broker, all of Derby Street, and also Samuel Evans of Moss View, who had family connections with the firm of Evans and Ball provender merchants, and William Hutton, printer and stationer of Fairfield Cottage. Peter Balmer was appointed architect, and it was decided that an ideal site would be on a bed of clay, so that the clay could be used to make the bricks for the factory. The required layer of clay was found beneath the land around what is now Elm Place, and so it was chosen for the development. The position was excellent; it was close to the railway, enabling the possible construction of sidings, coal for the steam engine was available in both Skelmersdale and Bickerstaffe, and there was plenty of cheap labour in the town. Lord Derby quoted very advantageous terms for the land, but he stipulated that he should have a percentage of the profit made if any of the bricks were sold. The mill was capable of working between 30,000 and 40,000 spindles, and there was also land available to build a weaving shed if it was needed.

Employment seemed guaranteed for the expanding population of the town, but the timing was wrong. The American Civil War had disrupted the cotton industry, the wages of the workers had been reduced and they had been put on short time. The consequent strikes meant that the existing mills were threatened with closure. In Ormskirk fewer shareholders than had been expected had come forward, and so in June 1877 the directors decided to dispose of part of the land for building. No doubt the builder who bought the land and erected the cottages in Elm Place intended them to house workers for the proposed cotton factory, but that was not to be. The following January the directors changed their plans and proposed a rope and bagging factory, but that too was never established, and the following April a liquidator was appointed to wind up the company.

The site of the proposed cotton factory, with the railway line close by.

The footings of the building had been dug and bricks had been made from the underlying clay. These had been sold to the public while the negotiations and sale of the company's shares proceeded. This project employed many local labourers and was very profitable, but the royalties that had to be paid to Lord Derby were heavier than the directors anticipated. Nevertheless, the success of the enterprise had encouraged the directors to plan the installation of brick-making machinery and to concentrate on that industry. However, before that was completed, the company had failed and the brick project had to be abandoned.

One trade that continued to be successful in the town until the twentieth century was rope making. The low-lying damp area around the town had been a centre for growing hemp since the middle ages and hemp yards were mentioned in several of the old charters. Rope made from hemp was a basic necessity in the days of sailing ships, horse transport and mills, and the townsfolk fulfilled that need by constructing rope walks, where long lengths of rope were twisted and produced in various thicknesses according to their purpose. The rope walks were so called because as part of the process one of the workers, with the rope attached to his harness, walked backwards from the engine house stretching the fibres, while his partner twisted the other end by means of some kind of wheel or engine. There

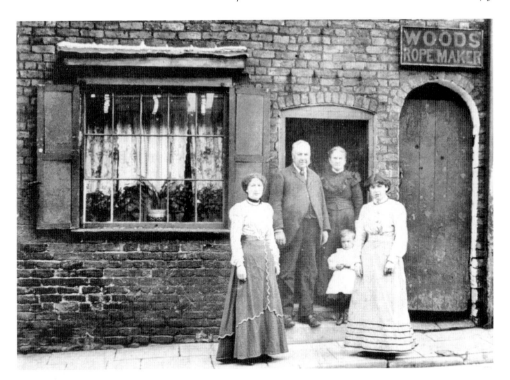

The Woods family, rope makers.

Edward Ormesher.

were several rope walks situated in the town. There was one behind Burscough Street, nearly opposite the home of the Brandreth family, one behind the property on the western side of Aughton Street and, of course, one alongside the Ropers Arms between Ruff Lane and Wigan Road.

Horticulture was also growing in popularity in the nineteenth century, as the more affluent members of society had time and money to spend on imitating the glorious gardens that surrounded the Georgian stately homes. To supply this demand, local people experimented in cultivating ever more beautiful types of flowers. One of the most successful local growers was Edward Ormesher, who cultivated a rose called Maréchal Niel. He spent four years perfecting the blooms in the greenhouse that he enlarged to cover 600 square feet on Wigan Road in Westhead. By 1888, he was able to cut over 1,100 blooms for sale. Perhaps the descendants of those roses are still growing in the district today.

More employment was created when the East Lancashire Railway Company extended their Liverpool to Preston line through Ormskirk in 1847. Unfortunately, in January 1850 it was the cause of an accident in Maghull involving several Ormskirk travellers. The 7.45 p.m. train from Preston to Liverpool had only one carriage and a very large crowd of passengers got onto the train at Ormskirk station. The staff decided to add a second carriage when the train reached Maghull, for in the siding there was an extra carriage that had been sent from Liverpool to accommodate several gentlemen who had gone skating on Sefton meadows.

Edward Ormesher's house, Whitfield House, on Wigan Road, where the roses were grown.

The train from Ormskirk was shunted in readiness on to the next line in Maghull station. As the spare carriage approached the stationary train, several passengers thought there would be an accident and panicked. They jumped out of the train into the path of a fast luggage train from the north on its way to Liverpool, and three passengers were killed, including Mary Leatherbarrow, née Croston, who was born in Gaw Hill Lane and left six children.

Another unfortunate accident happened to Ormskirk people earlier, in 1832, but this time it was not connected with the railway. George Bibby and William Aindow were drinking in a public house in Halsall when they began to quarrel about something that George had said about William's wife taking some cheese from him. William was angry and said that if George repeated that accusation he would knock him down. George unwisely repeated it, and so William struck his friend, who was smoking a clay pipe at the time, in the face. The blow drove the pipe about an inch into George's eye and he died ten days later. John Heyes, the coroner, investigated the case and passed it on to the assize court in Lancaster. The jury found William Aindow guilty of killing George and the judge sentenced him to one week's imprisonment in Lancaster Castle.

That was a very lenient sentence compared with the one given to John Prescott after he was charged with assaulting Richard Roberts of Rufford on 26 February 1857. The two men had been involved in a fight, and John had bitten off a portion of Richard's ear. John was taken to Ormskirk police station, where he was fined £5. He refused to pay his fine and the judge sent him to gaol for two months for contempt of court.

Another harsh sentence was given to Eileen Cooper in June 1857, when she was accused of stealing a pair of shoes belonging to Sarah Ryan of Bark House Hill (Southport Road). She was sentenced to a month in gaol, and after she had served that term she was to be sent to a reformatory for five years. Of course, we do not know whether Eileen had a history of committing petty crimes, but that sentence does seem very severe.

Ormskirk people also featured in a case that came before another court. In July 1849, Elizabeth Rimmer's sister gave birth to an illegitimate child in Ormskirk and, according to Elizabeth, her mother and her aunt murdered the child and buried it in front of their house door. Then when her grandmother died suddenly in October 1851, she was buried hurriedly in Ormskirk churchyard. The following year, when Elizabeth refused to help the family's finances by acting as a prostitute, she suspected that her mother and aunt were trying to poison her. She went to the police, and on 1 May 1852 the spot where the child had been buried was excavated. No bones were found but the soil was impregnated with a suspect substance, and a surgeon, who was asked for his opinion, said that after three years there would be no signs of the bones of a newborn child. Consequently, both the mother and the aunt were found guilty by the jury, but their lives were spared.

Another, less gruesome, case came before the judge at the Quarter Sessions. It was brought to the court by Henry Prescott and concerned a sovereign, which

Kirkdale Sessions 21st January 1833

Lancashire – Inquisitions taken by and before John Heyes Gentleman one of His Majesty's coroners for the said County of Lancaster since the time of the last Kirkdale Sessions on view of the several dead Bodies and at the several times and places hereinafter mentioned and for which he now applies to the Court to have the usual allowance

Miles		£	s	d
	No 1. 8th November 1832			
12	At Warrington of Margaret Clegg who was burned so as to occasion her death	1	9	–
	No 2. 9th November			
4	At Roby of Edward Tickle who was killed by a Cart Wheel passing over him	1	3	–
	No 3. 13th November			
17	At Halsall of George Bibby who was feloniously killed by William Amdow	1	12	9
	No 4. 14th November			
6	At Parr of William Burrows who was killed by the bursting of a cannon	1	4	6
	No 5. 15th November			
9	At Toxteth Park of a newly born Male Infant which was found dead in a Stone Quarry there	1	6	9
	No 6. 23d November			
6	At West Derby of Richard Ellison who died by the Visitation of God	1	4	6

The coroner's claim for expenses for investigating George Bibby's death.

he claimed he had put on a table in a public house. It was picked up by Peter Barton and Hugh Miller and never returned to him. However, when he was cross-examined, he admitted that he and his companions had been talking about fighting hens. Halfway through that examination he had realised that they had been acting against the law of 1835 which forbade cockfighting, and so he had altered his account to involve fighting hens. That caused the court to erupt into laughter, especially when he was asked by the judge, 'Come you must tell me something more about it, Prescott.' Henry replied, 'Can't tell anything more.' The group sheepishly altered their account and said the wager was that if any of them did not turn up at eight o'clock in the morning, they would forfeit the sovereign. Henry did not arrive until three o'clock. After that lame explanation, the judge ordered them to pay the costs of two shillings.

Gradually cock fighting retreated into secret locations in the countryside and the townsfolk adopted more active sports. As we have seen, skating was very popular, especially on Sefton Meadows, where the ground was flooded from the River Alt to provide a skating rink when the weather was icy. During the summer months, cricket was particularly popular in the town. In the early years of the century, it was played by groups of young men who gathered for a game, often before they went to work in the early morning. They worked such long hours that there was no time for a game after work. Consequently, they were christened the 'Break O' Day Boys'. Gradually, these groups of players formed clubs; the one in Ormskirk was founded in 1835.[2] The club's early fixtures were played at a variety of venues. At first they met at Mr Fairhurst's farm, later known as Woodlands Farm in Ruff Lane. Then, in 1863, the club moved to a ground on St Helen's Road, but five years later their matches were played on a field on Southport Road. Evidently, that too was unsatisfactory, for by the 1870s they had moved to Mr Bryer's field on what was to be Elm Place. However, as we have seen, the proposed cotton mill took over that location, and the cricket club finally moved to its present home in Brook Lane.

There are many stories about the early days of the club, but one concerning the father of Canon Robert Grayson is unusual. Seemingly, he was a very successful fast bowler, and one evening in the clubhouse Arthur Piggott challenged him to achieve a very high score in the match on the following Saturday. If he scored twenty runs, Piggott promised that he would buy him a new hat, if he scored fifty he would buy him a new suit, and if he scored a century his reward would be a new house. Grayson was determined to win the wager, so he tried to alter the batting order to prevent himself from being the last to bat, but that was not possible. In eighteen minutes his score was seventy-one and then the batsman at the other end was out, so, as he feared, he could not get the required hundred. Nevertheless, Piggott was true to his word and bought him a new hat and a new suit.

It is probable that the cricket field on Southport Road was part of the 12 acres that James Eastham later converted into the Victoria Athletic and Pleasure Grounds. It was very popular during the closing years of the nineteenth century.

Three generations of the Grayson family. The cricketer is on the right and Canon Robert Grayson is the boy in the centre, while his grandfather, also called Robert, worked for the *Advertiser*.

There were tennis courts, bowling greens, cycle tracks and a racing track for pony races. A pavilion was built for a billiard hall and for dancing, and two refreshment bars completed the facilities. Seemingly, this wonderful amenity closed during the First World War. Now all that remains to mark the site is a stone gatepost with the name 'Edenfield' to mark the entrance to James Eastham's house, which was alongside the Pleasure Grounds.

Many local men were members of the Hussars, the forerunners of the Territorials, and trained in Ormskirk, where musters of the militia had been held for many generations. James Eastham was regimental sergeant-major in the Lancashire Hussars, and realised that the recruits needed an indoor centre for their training, so he gave them the land on which the drill hall, now the civic hall, was built in 1899. They were fortunate to have James Nunnerley as their drill inspector from 1859 until 1881. He was an ideal choice for that post because he had served in the 17th Lancers since 1847, and had achieved fame during the Crimean War when he was one of the six hundred involved in the charge of the Light Brigade. He escaped without serious injury and continued to serve in the army. Then, two years after he had left the army, he settled in Ormskirk. He invested in four houses on Greetby Hill, which he called Alma, Inkerman, Balaclava and Sebastopol after the main battles. On the gateposts of those houses there are stone balls, which were put there to represent the cannon balls that were used in that war. The memorial in Victoria Park commemorates his bravery, and also that of three other local men who were

killed during the Boer War.[3] It is amusing that Mr Fairhurst of Woodlands Farm also commemorated one of the battles in the Crimean War in his own way, by calling his prize bull Inkerman. Mr Duff of Maghull bought it at Ormskirk Fair in September 1857 and shipped it on board the *Bellona* to Demerara, where it was hoped it would improve the stock of cattle in the settlement, which were chiefly small cows from Venezuela.

In 1881, Nunnerley opened a drapery shop at 27 Moor Street, next door to the Melia family, who had come from Ireland and had opened a beer house at 25 Moor Street. At No. 33 was the public house known as the Black Bear, where the landlady was Margaret Sutch, while at No. 39 was the Golden Lion, where the innkeeper was James Gerrard. With so many public houses, there was little wonder that there was a drink problem in Ormskirk. In January 1865, a public meeting was held and it was agreed that the Working Men's Reading and News Rooms should be opened in Burscough Street to combat the problem by providing a meeting place for men as an alternative to the public house, and also as a response to the self-help movement. Within a month, three hundred men had enrolled, and before long they needed bigger premises. Plans were made, and three years later they moved into their new building in Moor Street, which was known as the Working Men's Institute and Cocoa Rooms. It was a very popular venue for the townsfolk, who held events in the premises ranging from fundraising bazaars to performances of the Gilbert and Sullivan operas until the mid-twentieth century.

The gatepost of James Eastham's house, 'Edenfield'.

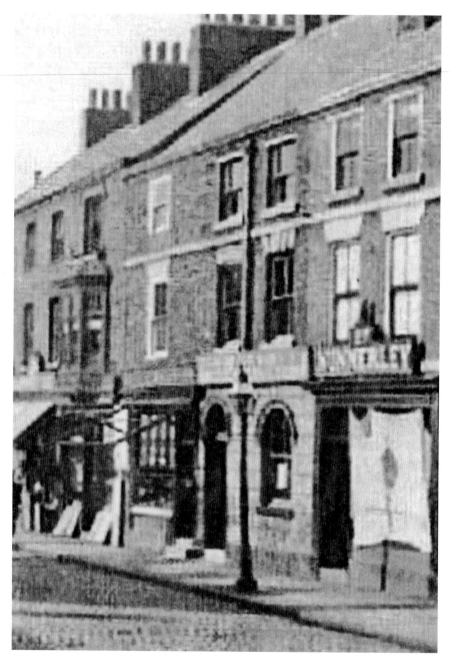

Nunnerley's shop in Moor Street.

Classes were also held there for adults who had not had the opportunity to attend school, or for those who wanted to improve their knowledge. Few townsmen could afford to pay the fees charged by private schools such as the Aughton Street Academy, founded in 1805, the Classical and Commercial Academy, founded in Burscough Street in 1825, the Mansion House Academy started by Reverend Thomas Harper in 1841, or St Leonards Collegiate School in Railway Road, founded in 1867. Even the free grammar school charged fees; for example in 1821, the eighty-year-old headmaster, Reverend Naylor, charged 7s 6d a quarter for an education based on a curriculum that included only the classics and English grammar.

The Revd Naylor was the subject of an article written by Peter Austin Nuttall and published in the *Gentleman's Magazine* in 1828. It concerned a barring out that had taken place earlier in the century at the grammar school against the 'flogging parson', the Revd Naylor. Forty boys led by William Bibby, the son of Dr Bibby of Church Street, went into the school at 7 a.m., nailed up the windows and barricaded the door with desks and forms. When Revd Naylor arrived at 9 a.m., he was greeted with a volley of sticks and stones. The headmaster retreated and returned with the local parish constable. The revolt soon ended, and the victors went into the school between two rows of scholars who had given up the fight, while others scrambled through the back door and the windows and ran away, never to return. Nuttall was one of the culprits involved in that escapade, and despite this revolt against his headmaster, he had learnt to appreciate the classics. This laid the foundation for his life's work of interpreting the classics and publishing various articles, culminating in his great work, now known as *Nuttall's Standard Dictionary*.

The grammar school's premises in the churchyard were condemned in 1828 and the school was housed temporarily in the premises of the charity school that was founded in 1724 in Church Street. However, in 1850 new premises were opened in Ruff Lane and the eighteen scholars that remained in the school moved into their new home. Soon afterwards, the fortunes of the grammar school began to improve.[4] The united charity school also moved into new premises in the 'model' school, now Stokers building, in Derby Street. It is probable that night school classes were also held there, for on 26 February 1857 a notice appeared in the *Advertiser* claiming that 'The evening schools were to close after a successful winter. Arrangements have been made for the circulation of books from the parochial library in Derby St. among these classes. This will be one great means of increasingly benefiting the working classes in putting into their hands books of useful, moral and religious character free of cost.'

It is possible that one of those books would have been the magazine *The Ormskirk Yeoman*, which was published by William Guest, who was a keen supporter of the temperance movement. He had been trained in Stroud as a printer before moving north and taking a post with the *Ormskirk Advertiser*. He was ambitious and started his own business as a printer and bookbinder, but unfortunately it was not a success and he was forced to sell out to his former employer, the *Ormskirk*

Advertiser. He was a talented organist, and so was welcomed to play in many of the local churches.

He may have played in the new church that was built for the Catholics who had worshipped in the chapel of St Oswald in Prescot Road since 1795. After several years of fundraising, they were able to celebrate the opening of their new church, which was dedicated to St Anne, in 1850. At the very beginning of the century, the Methodists had formed a local group after gathering to hear Thomas Taylor and Adam Clarke preach in the open air from the fish stones. Later, they held meetings in a room over a rag warehouse, where according to the preacher James Holroyd, 'Our present preaching house is a very uncomfortable place … in the summer the livestock from beneath are very troublesome, our good ladies complain of having to undress at their return to catch and kill.' From there they moved into a new chapel on Chapel Street, but it was not long before those premises were also found to be too small, and after a lot more fundraising the members were able to build the present Church of Emmanuel on Derby Street. It was opened on 28 March 1878.[5] At about the same time, the parish church underwent a great programme of restoration.

Another new church, now the Community Centre, was established by the Independents, later known as the Congregationalists, and was opened on St Helen's Road in the 1830s. One of their earliest ministers was William Rutter Dawes, who later became a famous astronomer. His first observatory was set up in Ormskirk, and while he was in the town he was made a fellow of the Royal Astronomical Society. He published several papers and, as a consequence, was invited to work as a paid astronomer for George Bishop, a wealthy wine merchant in London. That meant leaving Ormskirk in 1839, but not before he had formed a relationship with Mary Ann Copeland, the widow of John Welsby, an Ormskirk solicitor, whom he married in 1842.

Another Ormskirk solicitor, Sam Brighouse, was one of the last coroners to be elected before the process was abolished by the Local Government Act of 1888. Two solicitors, Henry Linden Riley of St Helens and Sam Brighouse, were candidates for the post and an election was organised to decide which of the two should take the post in January 1884. The election was fought in much the same way as a general election. The candidates toured the area soliciting votes, addressing meetings and publishing a vast amount of material; in fact, it was said that the campaign cost each candidate no less than £2,000 at a time when houses could be bought for as little as £100. The Ormskirk candidate was successful and celebrations began in the town. Crowds collected at the Kings Arms, the campaign headquarters in the town centre, to celebrate the victory, no doubt at Sam Brighouse's expense. It is said that the supply of eatables in the town ran out and all the licensed premises almost exhausted their stocks. However, it is doubtful whether those who really needed the bonanza benefited from it. Sam Brighouse remained the coroner for the district for many years; in fact, he attended the inquest on 9 May 1907 into the death of Edwin Johnson, an engine driver aged fifty, who lived at 58a Burscough

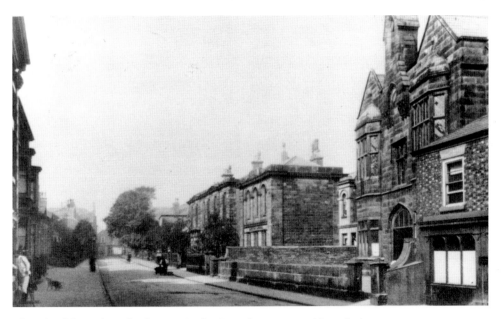

The school for girls and infants in Derby Street later coverted into Stokers store.

Sir Sam Brighouse, a coroner, taken in 1931.

The train that struck Edwin Johnson.

Street. This was another tragedy connected with the railway, as he was killed when he was struck by the engine of a special train in Ormskirk station.

Behind the properties in Moor Street were two of the many courts of small cottages that abounded in Ormskirk. The one behind Nunnerley's shop was called Prescott's Yard, while the other was named after the Black Bear. Altogether, 148 people who were born in Ireland lived in Prescott's Yard in 1861. Most of these worked as agricultural labourers, although one or two of the womenfolk worked as dressmakers or seamstresses. For many, many years Irish labourers had been in the habit of spending their summer months labouring in the fields surrounding Ormskirk, and they looked upon the town as their second home. Therefore, when the potato famine struck in the 1840s, they brought their families to the town. Those who had the means set up lodging houses, where their compatriots lived in extremely cramped conditions. Unfortunately, many were ill when they arrived, and the sickness spread throughout the town. By 1849, the rate of mortality from cholera, diarrhoea and fever in Ormskirk was higher than the worst district in London, and many of the dead were the Irish immigrants. The townsfolk were in need of help, and so in desperation a group of 169 ratepayers appealed for an inspector from the Board of Health to visit the town with the view of setting up a local board of health. Dr Marsden was sent to inspect the town and his report paints a horrifying picture of conditions in the town.[6]

Altogether, he listed nine lodging houses in Prescott's Yard and described all except one as dirty houses. The worst had only two rooms and was the home of a family who had taken in two lodgers. According to Dr Marsden, it was 'a wretched hovel; a midden and privy underneath the bedroom'. For all those people and their children in Prescott's Yard there were only two pumps and three privies in the yard. The inspector commented that many of the townsfolk paid no attention to cleanliness or ventilation, while open middens, pigsties and cess

pools were crowded around the dwelling houses. The town's sixty lodging houses were inspected and comments were made on their condition. They ranged from 'Wretched beyond description', 'A wretched hovel; only one room for all purposes' to 'Filthy – past description; surrounded by privies and middensteads', and 'a miserable hovel covered with filth'. Inevitably, he found that the great mass of the fever cases brought into the workhouse were Irish people from those crowded lodging houses. During the public enquiry at the town hall, James Palmer said, 'The conditions of the Irish lodging houses is most abominable. Have frequently in passing, crossed the road, the smell from them has been so horrid. Had to survey a district and could not tread for human refuse; even where privies exist they are in the most disgusting condition.' It was found that in Nursery Yard off Aughton Street, the refuse of two pigsties and a midden at the top of the incline oozed through into the dwellings. The problem was exacerbated by the local tradition of poor people keeping their refuse for a whole year on their premises hoping to sell it to the farmers as fertiliser. According to Dr Marsden, disease was generated by these large heaps of refuse that were stored until fermentation took place.

In his report, he stipulated that there was a great need for sewers and for an abundant water supply for the town. Although some attempt had been made to drain into the fields behind some of the properties, most of the few drains that did exist drained on the surface into the street. For a population of 4,891 there were only eighty-five water pumps, most of which were contaminated by surface water, leaving only ten that were deemed fit for use. Of those ten, only four could be classified as good-size pumps from which the townspeople could obtain their supplies. These were located at the bottom of Church Street, on Aughton Street, approximately where the traffic lights are now, on Moor Street, opposite what became Taylor's shop, and in Burscough Street, near the present library.[7] There was also an iron dish well near the Comrades Club, where an iron dish and ladle was attached to the wall. Some private wells were available to the public, but the owners of those pumps charged sums usually between two and three shillings a year – an almost impossible sum for those on the breadline. In one case, despite receiving that payment, a gentleman, the owner of a public pump who needed great quantities of water for his business, ruled that anyone who used his pump must make sure his cisterns were full before they pumped any water for themselves. The inspector noted that in one place, 117 people were waiting for water from one pump and another resident, Gould Tilsley, claimed that he supplied over 100 families from his pump. During the enquiry, Joseph Lyon remarked that there was not a bath in the whole town, not even in the dispensary, owing to the want of a water supply.

The inspector also recommended that the graveyard should be closed as it had been used for 200–300 years, and was so full that it could not be disturbed to the depth of one foot without turning up some mouldering remains. The inspector observed that 'noxious exhalations which arise from the constant upturning of this animal matter is poisonous in itself and injurious to health as well as to decency'.

He also suggested that the slaughter houses should be moved some distance from the town.

Amazingly, one section of the population opposed the proposition that a local board of health should be set up. However, the spread of cholera caused panic in the town and silenced all opposition, and the board was set up in 1850. The Tower Hill waterworks was constructed, and by the end of 1854 about 700 houses were using the public water supply. Extensions were made to the works both in 1855 and in 1879, and at last Ormskirk had a good supply of clean water.

Nevertheless, problems concerning the lodging houses continued to be brought to the Ormskirk Board of Health. In 1857, the local newspaper reported that the committee had dealt with, 'Several cases of lodging house keepers for permitting persons of opposite sexes to sleep in the same room … all of which were excused with a caution.' Many health and behavioural problems still faced the townsfolk. One, which was reported in 1870, concerned the fishmongers and the cleanliness of the marketplace. Evidently, 'Fish entrails in various stages of putrefaction lie exposed all the day and night, the (urchins) of the gutters amuse themselves by throwing them at each other and at passers by.'

Poverty also continued to be a problem in the town and the surrounding area. The old workhouse on Moor Street was the only place where the poor who were too sick to look after themselves could be taken, and it was also the only refuge for those Irish immigrants who could not afford the rent for a room in one of the appalling lodging houses. A total of 633 people suffering from fever were taken to the workhouse during 1849, and most of them had to be put into a temporary shed because they had to be isolated. Once the local board of health was established these conditions improved and a new workhouse, later to become Ormskirk County hospital, was built in Wigan Road in 1853.

Earlier, in 1832, the dispensary had moved from its original home in Lydiate Lane into a brand new building in Burscough Street, despite some unforeseen legal wrangling. When Joseph Brandreth died in 1814, he left the whole of his estate to his wife Catherine, who, despite moving to Toxteth, never forgot her days in Ormskirk. When she died in 1827, she left £200 (the equivalent of £14,000 today) for the poor of Ormskirk. Her son and executor, remembering his parents' interest in the dispensary, decided that the money should be used to build a new, purpose-built dispensary to benefit the poor, and the beautiful neoclassical building was opened in 1832. However, the vicar, Revd Horton, challenged the decision in the court, declaring that the money should have been distributed to the poor. The court found in favour of the vicar and the dispensary had to return £180 in 1842. This was invested and the interest was used to provide flannel for the poor of Ormskirk parish. Undeterred, the dispensary continued its work supported by charitable donations until 1896, when it was combined with the cottage hospital in Hants Lane, which was opened that year. The neoclassical building was sold and became the farmers' club, which continues today.

Before the building of the cottage hospital, doctors had complained since 1880 that they needed somewhere to treat patients who had to be confined to bed.

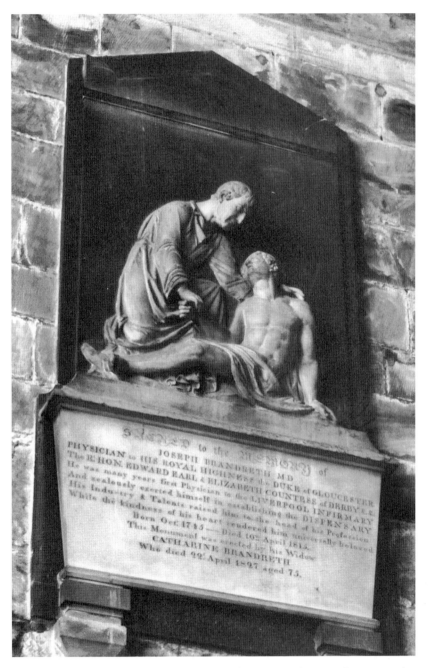

The memorial to Joseph Brandreth erected by his widow, Catherine, in the Parish Church.

Latlhom House,

August 31st, 1885.

We wish to express our warmest thanks to you for the part you have taken in subscribing towards the beautiful Silver Salver presented to us, by the Agents, Servants, Workmen, and others on this Estate, on our Silver-Wedding Day; and to assure you that your handsome gift will always be greatly valued, and the kindly feeling displayed on this occasion ever gratefully remembered, by your sincere friends,

A card sent by Lord and Lady Lathom to thank those who donated money towards the silver salver that was given to the popular couple on their silver wedding anniversary in 1885.

Of course, there was no National Health Service, so again the funds for the new hospital had to be provided by charity and two succeeding Earls of Derby donated the site for the building. The hospital was originally to be named the Lady Lathom Memorial Hospital, to commemorate that lady, who had died tragically after the wheel of her trap caught the edge of the bridge at Cobbs Brow. The trap overturned and she was thrown into the River Tawd and killed. She was very popular and today she is remembered in the name of Lady Alice's Drive in Lathom. Several of her friends contributed to the fund, while local people resorted to various means of raising money for the project, and eventually the cottage hospital could be built. No-one was to be refused treatment and only those who could afford to pay were charged a fee.

One of the doctors who tended patients in the cottage hospital was Dr William Anderton, who lived in the Mansion House in St Helen's Road. He held the post of Medical Officer of Health for Ormskirk for forty years. One of his duties was to vaccinate the public against smallpox, thus helping to eradicate that disease from the town. Florence Nightingale's work in the Crimean War had made the medical profession realise the importance of training nurses, and Dr Anderton pioneered the training of local nurses by arranging lectures and training sessions. He married Emma Balmer in 1872, and two of their three sons entered the medical profession.

In those days most people used to try traditional remedies before they went to the doctors when they had a troubling cough or a sore throat. Recently, an old recipe book containing several old remedies was discovered among the papers of the Mawdesley family. This was the cure recommended for sore throats:

> Mix one pennyworth of pounded camphor with a wineglass full of brandy. Pour a small quantity on a lump of sugar and allow it to dissolve in the mouth every hour, the third or fourth dose generally enables the patient to swallow with ease.

For coughs it recommended either:

> White wine vinegar, tincture of opium, spirit of ether, 1 common dose of jalup (opening medicine) and treacle.

Or:

> Vinegar, treacle and thirty drops of laudanum in a great glass of rum.

There was another recipe to cure a bowel complaint given to the family by Mr Yeoman of the Wheatsheaf in 1868:

> Tincture of opium, oil of peppermint, spirits of lavender in a tumbler of warm water.

Evidently, according to a note, Mr Yeoman had said that a chemist had advised him this was too strong and must be used with care. The aim of these remedies seems to have been to make the patients unconscious of their pain, not to cure it.

The existence of the new workhouse enabled the authorities to help relieve the situation when the town experienced a serious rise in poverty in the 1880s. They set up a soup kitchen, but conditions worsened so much that in 1886, Superintendent Jarvis and the local police organised the distribution of several thousand meals from their headquarters in Derby Street. Throughout January the following year, the police provided 300 suppers each night, when 'scores of poor starving children almost ready to perish with cold and hunger' were fed. Statistics reveal that 50 gallons of soup and over 200 loaves were consumed each week. The situation continued until 1902, and it was necessary for the police to man a soup kitchen for three nights each week to feed the hungry. One person who profited from these hard times was the owner of Holborn House, a mansion which stood opposite the windmill on Holborn Hill. He was the local pawnbroker and his house was known locally as 'pop' castle.

A casualty of this time of shortages was George Bibby, aged seventy-eight, who left his home in Gregory's Yard, Ormskirk, at about nine o'clock on the morning of Saturday 11 February 1871, telling his wife that he was going to Snape Green

and would be back home early. As he did not return, she sent two boys to look for him, but they could not find him. However, at about half past ten in the evening, as James Taylor and several other people were going to Scarisbrick, they saw Bibby lying on the roadside near Thomas Heaton's house. Taylor lifted the old man up, and assumed that he was drunk for he had lost the use of his legs. He was alive, so they bade him 'Good night' and left him. Taylor and his nephew returned shortly afterwards, intending to take the old man home, but when they got to him he was dead. The police were called and the body was moved into Thomas Heaton's house. It was reported that the old man had not a farthing in his pocket and it was thought that he died of starvation. Nevertheless, the jury returned the verdict that he had died from exposure to cold.

Another family who had a great struggle against poverty was the Kiggins family, and their experiences were echoed in many households in nineteenth- and early twentieth-century Ormskirk. Alice Kiggins was the second daughter of Henry and Elizabeth, née Hignett. When Alice was six the family left Skelmersdale, where Henry had been earning a living as a farmer, and moved into Ormskirk, where he became a carter. The family lived in Green Lane, among several Irish families in a small, two-up, two-down house with an outside privy. Unfortunately, Henry died in 1879 when Alice was ten, leaving his wife pregnant with their sixth child. However, Henry's brother, James, who had been living with the family, began a relationship with Elizabeth and they married two years later. Before very long three more children were added to the family. James was only a labourer, so they had very little money. As a result, Elizabeth opened a shop in the front room of her little house, while Alice was kept at home to help in the shop and look after the other eight children.

At the age of twenty-two Alice married Henry Dann, a painter, and the couple moved into another tiny house, off Southport Road. The following year the first of her ten children was born. Sadly, one of her children died at the age of two and her third son was killed in the First World War, but the others survived. In the early 1900s, the family moved into 27 Hants Lane, a larger house to cater for their growing family. They also had a lodger, Harry Jennion, a relation of Alice's sister, whose parents had died while he was still very young. He had nowhere to go, so Alice took him in, and as he never married, he lived with the family for the rest of his life. Even with four rooms downstairs and four double bedrooms, the house must have been very crowded with a family of ten and a lodger. In those days, when there were no social services, it was common for families to welcome distant members of the family into their homes if they were in need. It was thought that to be admitted to the workhouse was the very last resort, which almost brought shame upon the whole family. As soon as finances permitted the Dann family rented a large field behind their house, and part of it was used as a smallholding and for their pigs, while the other part was kept as a field for horses. The produce from the smallholding provided food for the family, and any surplus was sold to their neighbours.

No. 27 Hants Lane.

Henry had an accident at work and broke his shoulder, and unfortunately it was not diagnosed immediately. Consequently, he was crippled and unable to work again. In desperation, Alice applied for outdoor relief from the workhouse, but was given only 48p a week. When she pleaded for more help, she was told to sell her precious piano, which was her only luxury and had pride of place in the living room.

Undaunted, Alice followed her mother's footsteps and opened a shop in her front room. As soon as she was able, she bought a pony and trap so that her son William could drive to the market in Liverpool and buy produce for the shop. Whenever it was possible she would buy a complete field of vegetables or a crop of fruit, and when the crop was ripe she would send the children and later the grandchildren out into the fields to dig up, pick or cut whatever crop it was, so that the produce could be sold in the shop. Many of her most loyal customers were the children from St Anne's Catholic Junior School opposite the shop, who would call in after school and buy apples or sweets.

Alice was very strict with her family and Henry only intervened when he thought she had gone too far in chastising the children. One notable occasion was when their eldest, seventeen-year-old, unmarried daughter became pregnant. The first thing Alice did was to go round to the house next door where the new father lived, and give him a good hiding. Her daughter also got a good hiding and every time anyone came

Henry and Alice Dann.

A Victorian family celebration on Charles Medcalf Warlow's twenty-first birthday. Back Row: Peter Holcroft, George Warlow, Nelly Quickshanks, Nancy Esther, Nelly Metcalf, George Esther, Bessie Warlow, Nelly Medcalf, Thomas Medcalf, Charles Warlow, Michael Cook, Jessie Brighouse, Miss Holcroft, Harold Roberts, Amy Warlow, Tantie Brigouse, Lucy Brighouse, Thomas Warlow, Alice Brighouse. Middle Row: Nelly Stretch, Polly Brighouse, Harriot Medcalf, Grandfather Charles Warlow, Grandmother Margaret Warlow, Aunt Chalmer, Great Granny Elizabeth Medcalf, Margaret Stretch, Hannah Benyon, Thomas Holcroft, Mrs Henry Brighouse, Amy Stretch. Front Row: Thomas Medcalf, Margaret Warlow, Ethel Warlow, Elsie Warlow, Hilda Warlow, Ernest Warlow Edmund Warlow.

to the house, she was sent down into the cellar in case she would be seen. Henry eventually intervened on behalf of the couple and they were allowed to marry. Even when her many children had left home, Alice continued to run the shop until her health deteriorated when she was in her seventies, and she died at her home in 1941.

During the last years of the nineteenth century, there were two occasions when the people of Ormskirk had good reasons to celebrate. Queen Victoria had emerged from a long period of mourning and her people were ready to mark the fact that she had ruled over them for fifty years in 1887, and then in 1897 there was her Diamond Jubilee to commemorate. Miss Martin, who was born towards the end of the nineteenth century, lived in the house that has become the NatWest Bank. She remembered being taken to watch the celebrations to mark the Diamond Jubilee. Bonfires were to be lit on the tops of all the nearby hills, including Ashurst Beacon and Harrock Hill, and Miss Martin's father wanted her to witness the scene. He took her to Fletcher's mill at the top of Holborn Hill and carried her up the wooden spiral staircase to the top of the mill, from where they watched the bonfires light up the night sky.

Similar celebrations at the turn of the century were remembered by two members of the Constantine family. During the first phase of the South African War, there had been a series of Boer successes as British garrisons were besieged in Ladysmith, Mafeking and Kimberley. Then, in February 1900, the tide turned, and gradually each of the garrisons was relieved. In Chapel Street in Ormskirk, the two Constantine children had been put to bed when the news came through that Ladysmith had been relieved. They were woken, dressed and taken into the town centre to see all the festivities that were happening to celebrate the victory. Many of the town's men had enlisted and so the celebrations had added significance. The men would be coming home soon – a real reason for the people of Ormskirk to celebrate.

Notes

1. For these totals and similar statistics in this chapter see F. W. Stacey, *Ormskirk a History*.
2. Kenneth Lea, *175 years of Ormskirk Cricket Club*, p. 18.
3. For further detail of the bravery of these men see Mona Duggan, *Ormskirk: A History* (Phillimore, 2007), p. 128.
4. For more information about the grammar school see David Orritt, *The History of Ormskirk Grammar School Lancashire* (Carnegie, 1988).
5. Mona Duggan, *The History of Methodism in Ormskirk*.
6. Robert Rawlinson, *The Ormskirk Board of Health Report, 1850*, with an introduction by Audrey Coney, 1991.
7. Report of Ormskirk Urban District Council on the centenary of the waterworks undertaking 1848–1948, p. 22.

Chapter Five

The Memories of Ormskirk People in the Twentieth Century

The advertisements that appeared in the local paper in 1910 illustrate how much our lives have changed in the last hundred years. On 13 January Stokers, who were then in Nos 5, 7 and 9 Burscough Street, advertised:

A Wonderful range of new furs
A new stock of wraps and shawls
The largest stock of flannelette blouses in the district
Gloves to fit everyone by the thousand
A tremendous stock of new pinafores and aprons.

Hundreds of gloves, flannelette blouses, wraps and shawls, furs and pinafores would hardly attract customers today. Then followed the promise that, 'We shall be making the biggest display of Christmas cards yet seen in Ormskirk', a strange claim to make in January. Certainly, Stokers have changed with the times. Now they advertise dining suites, bedroom furniture and office equipment, and have moved into the former Derby Street school, and also into even larger premises in Southport.

An advertisement inserted by Garside's, who had a shop in Aughton Street, was also typical of the times when it claimed, 'Instant death to rats and mice by using Garside's Vermin Killer.' They knew that many of their customers suffered from invasions of rats, mice and other unwanted pests and if any of their customers wanted more help to get rid of them, the phone number was 27. Evidently there were very few phones in Ormskirk before the First World War.

On one Bank Holiday Monday about that time, there was a gala in Ormskirk, and the main attraction was one of the first moving picture shows. A huge screen

The town at the beginning of the twentieth century.

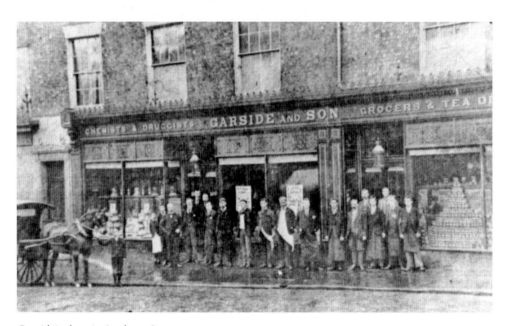

Garside's shop in Aughton Street.

Mr and Mrs Garside, who opened the shop.

was set up in Aughton Street, and at nine o'clock the show began. The crowds in the street could view the short films of such things as the London fire brigade turning out from either side of the screen. The film was fed through the projector, and then it fell in loops into a large basket. After each film the audience had to wait until it was rewound before they could watch another short. Later on, films were shown in the Institute where there was a large room upstairs that was leased to anyone who wanted to present shows. For instance, in the *Advertiser* for February 1910, there was an announcement about the 'animated pictures' that were to be shown. The short films that were to be changed twice a week on Mondays and Fridays included a strange assortment, such as *The Way of the Cross*, *Boxing Fever* and a short film about the development of a chicken inside the egg before it was hatched. These were interspersed with live performances by a Japanese troupe and a juvenile vocalist.

However, shortly before I read that advertisement, I had been told that one day in November, many years ago, James Smith from Bickerstaffe had a visit from a member of a Japanese variety company which had leased the upper room. They desperately needed a pianist and had been told that there was a farmer's son who might be able to help them. They wanted him to accompany the silent films that they showed between their variety acts, and also to play before their performances began. James agreed to do so, but found that the continual hissing noise from the generator that powered the projector was very distracting. It is probable that this was the same company that advertised their second visit to Ormskirk in February 1910, and also launched James Smith's career as a pianist in the early cinemas in November 1909.

When there were no other bookings for the upper room, Mr Locke, a tea merchant from Liverpool, hired the room for a low fee and showed various short films consisting of one reel only and hired James to play for them. One night, the projectionist put the film too near to flames and it caught fire. After the blaze, Mr Locke lost his licence and was told that unless he made an outside box for the projector, it would not be renewed for safety reasons. Consequently, he erected a new room and installed two projectors so that the programmes could continue without pausing to rewind. Although James sometimes used sheet music at the beginning of the film, he usually had to extemporise later in the showing – always bearing in mind that his Ormskirk audience preferred classical pieces. He would begin with 'The Washington Post' and then carry on, trying to match the mood of the film. During the eight years James played at the Institute, Mr Locke showed twelve Chaplin films, which were great favourites with the townsfolk.

The *Advertiser* also reported this snippet of local news on 3 March 1906:

A clever feat of horsemanship (or horsewomanship) was witnessed this morning in Ormskirk when Miss Brocklebank of Woolton returning from a coaching trip in the Lakes drove four horses and a stage coach up the "Wheatsheaf" Hotel yard without a scratch. Only those familiar with driving and the limited width of

The Institute.

Burscough Street and the yard referred to, can fully realise the difficulties of such a feat, which it is supposed had hitherto never been attempted and was thought to be impossible …

Seemingly, Miss Sylvia Brocklebank, daughter of the owner of the shipping line, was taught to turn a coach in a narrow place by Edwin Howlett, and afterwards the entrance into Wheatsheaf Yard, which was only 7 feet 11 inches in breadth, was known as 'Howlett's corner'.

Many local drivers lacked the skill needed to drive horse vehicles safely, as two other news items described in 1910. Joseph Grayson was fined 2s 6d for riding on the shafts of a vehicle without having reins. Of course, some horses were so familiar with their routes that they could find their way unaided, but it certainly was not safe in a busy town. The other item concerned a collision that occurred near the Beaconsfield statue in Moor Street between two horse-driven vehicles, one belonging to Mr J. A. Williams of Burscough Street, and the other to Mr. J. Ball of Bickerstaffe. Shortly after the crash, one of the horses died because the shaft of the other vehicle pierced its chest, but neither of the drivers responsible for the crash was hurt. Perhaps it was this lack of skilled drivers that persuaded more of the townsfolk to hire coachmen, horses and carriages from people known as jobbers on a monthly or yearly rental.

Another accident concerning a different form of transport occurred in 1904, when Thomas Huyton was going home from the Kicking Donkey after spending the evening in the pub with his friend William Moss. A penny farthing bicycle came towards them and William warned his friend to get back onto the footpath. Unfortunately, the bicycle was too quick for him and both cyclist and Thomas were knocked to the ground. The cyclist got up unhurt, but Thomas died as a result of the fall. At the inquest William described his friend as being a 'bit fresh', but not drunk nor quick enough to avoid the accident.

In the mid-1800s, steam power was introduced to the town and was harnessed for the mill on Church Street – behind what is now Tesco's store. In January 1900, it was decided to buy a steam fire engine to serve the town and the surrounding townships. To house the precious vehicle, a new fire station was built in Derby Street West – on the site of what is now the Stiles car park – to replace the one near the Mansion House on St Helen's Road.

Before very long, those who could afford to do so bought a car. One of those was Dr Pendlebury, who, it was said, owned the very first car in Ormskirk. According to some of his patients, it made such a noise that the patients were able to jump back into bed when they heard him coming. The doctor treasured his car and was very disappointed when Dr Craig bought the practice and refused to buy his beautiful coach-built Windsor car. It was truly elegant, but it was so heavy that if the hood was up, it could hardly climb Holborn Hill.

Dr Pendlebury lived in Knowles House, the site of today's library, and over his bed was a speaking tube through which night-time patients could call to awaken

Miss Brocklebank driving the four-in hand and coach out of the Wheatsheaf Yard.

Joseph Bradley, who operated a cab service from Town Green station for sixty years.

The old fire station in Derby Street West.

him if there was an emergency. He tended the Earls of Lathom and looked after the staff and workmen on the estate. Whenever it was necessary, the Lathom coachmen would call for the medicines that were required. The doctors dispensed them in square bottles so that they would not roll about in the trap as it drove back to Lathom. Dr Craig admitted that he used the same practical, square medicine bottles until 1948.

As there were no consultants in the cottage hospital, the doctors had to send a message to the Liverpool Hospital for them to come out to Ormskirk whenever one was needed to perform an operation. The surgeon Mr Rawlinson, who lived in Hoylake, was always ready to come immediately to Ormskirk, even before the opening of the Mersey Tunnel. The doctor on duty at the cottage hospital would phone him and he would drive down to the docks, 'toot toot tooting his horn' – according to his son – to let the ferry man know that he was approaching. Meanwhile, the duty officer would phone the pier head to warn them that the surgeon was on his way. As there was only one boat an hour during the night time, he would hold the boat until Mr Rawlinson arrived.

All these new cars needed servicing, so Mr W. Biggs set up his garage in Back Derby Street West, and one of his customers was a certain well-to-do lady who regularly took her car into the garage. She used to leave a half crown under the carpet to test the honesty of the mechanics. The staff were aggravated by this ploy and decided to reply in their own way. They drilled a hole in the half crown and screwed it down to the floor. The lady was extremely angry and the two mechanics almost lost their jobs.

The brass plate in the parish church commemorating Dr Pendlebury.

Mr W. Biggs outside his shop.

The Thompson family, who owned the local haulage firm, gradually converted their horse-drawn wagons, at first into steam wagons and then into motorised vehicles. In the early days, the firm, founded by Richard Chadwick, had over fourteen draught horses. One of their first contracts was to carry coal from the station to the gasworks, but any kind of haulage work was welcomed. Later, the business passed down the family to the three brothers Harry, Roy and Alan Thompson, whose mother was a true matriarch. Under her guidance they moved into the removal business and agreed to share the responsibilities. Harry was responsible for much of the driving, and he recalled being booked by a policeman for driving at a speed over 20 mph – the speed limit at that time. Many Ormskirk people remember that one of the lighter sides of moving house was listening to the Thompson brothers as they reminisced about moving various Ormskirk families to their new homes.

When the First World War broke out many Ormskirk men enlisted, and their wives and daughters were left to 'keep the home fires burning', as they did in most of the towns in Britain. However, Ormskirk had an extra role in supporting the remount depot based at Lathom Hall, which Lord Lathom had placed at the War Office's disposal. Horses bound for the battlefields of Flanders were prepared for battle conditions at the depot. The force was divided into squadrons of 500 horses with one superintendent, two assistants, six foremen and 150 grooms, riders and smiths. In the early days, it was organised on a civilian basis, so many of those

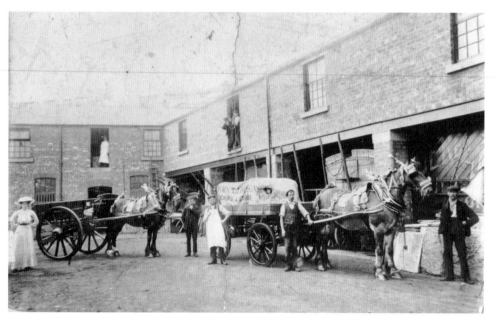

The Thompson family's horse-drawn haulage firm.

The Thompson family gradually converted the horse-drawn wagons to motorised transport.

Photograph of the Bampton family taken in 1918. Barbara, the little girl on the left, remembers her father bringing army biscuits home for her.

serving at Lathom would be men from Ormskirk. However, when the depot was 'militarised' in January 1915, the majority of the men who were working there enlisted and their foremen became NCOs. The horses destined to serve in France arrived in Liverpool dock on several ships which had been refitted for the purpose. One, the *Indore*, was altered to provide transport for 1,030 horses from Canada. At first the horses were brought to Ormskirk station and then taken to Lathom, but later in the war a special line was built that terminated inside the camp. Between September 1914 and November 1917, the depot received 215,313 animals, and over 5,649 men passed through the depot on their way to France with the horses. Although the camp was equipped with canteens for the men, they were always glad to escape from that environment and go into Ormskirk. Among those who welcomed them were the members of Emmanuel Methodist Church and, although I do not know what was done for the soldiers, they were so grateful that they presented a certificate to their friends at the church, thanking them for their kindnesses. The certificate was signed by thirty men, who wanted to include many of their comrade's names who had been posted overseas. Interestingly, a search through the records revealed that none of those who signed were lost in battle.[1]

In the local workplaces, the men who enlisted were replaced by the womenfolk of Ormskirk. They were also employed in new factories that were opened to supply munitions and the other needs of a country at war. One of these new factories was Hattersley's. R. E. Hattersley from Halifax had married Sarah Potter of Moor Hall, Aughton, in 1902. They had settled in Ormskirk and he had opened an office in the

Published by E. Spencer, 20, Church Street, Ormskirk.

Kings Arms
Ormskirk
7/3/15

Dear Willie
 I thank you for
the P.C. you sent me, and pleased
to hear you are quite well. Sorry
to say we have had Ma in bed
for a month with Rheumatism.
But is now improving. The last
squad of the Ormskirk Terriers
have had their leave this week,
and are expecting to go to France
next week. Your turn next I should
think. When may we all expect to
see you. I hope it won't be very long.
Millie and Rhoda send their best
wishes to you. Trusting you may have
a safe and speedy return. With
kind remembrances from all at
home. Yours sincerely Ethel

The back of the postcard from the Kings Arms from Ethel to her brother (?)
Willie in March 1915.

The certificate presented by the men from the Royal Service Corps, the Royal Veterinary Corps and the Royal Ordinance Corps at the remount depot.

town so that he did not have travel so often to his factory in Halifax. When war broke out, the Ministry of Munitions made great demands on engineering firms to switch to the production of war materials, and it was decided, with the backing of the Ministry, that a new factory should be established in Ormskirk. Although the engineering firm had previously employed a male workforce, the factory was staffed almost completely by women during wartime. Their long gowns and loose hairstyles could have caused serious accidents, so the women had to wear caps and aprons to prevent them from being caught in the machines, or in the belts from the shafting that powered the machines.

Ormskirk's steam corn mill was taken over during the war and was converted to make mattresses for the troops. Again many of those whose husbands had enlisted were employed at the mill to help the war effort. However, in 1918, the building caught fire and the blaze was one of the biggest in Ormskirk's history. About five hundred Ormskirk boys remembered it well, for they were caned for stopping to watch the fire when they should have been in school.

After the war, normal life in Ormskirk resumed. By that time the rope works of H. and J. Jones, which gave the name to the Ropers Arms, was a large concern with twelve rope walks, one stretching from Wigan Road to Ruff Lane, and included the Old Mill, the New Mill and the Top Mill. It had been in great demand during wartime, making all kinds of ropes for use by the troops. The works expanded and yarn from all over the world was spun into a wide range of products. One day in 1925, Tommy Judge, one of the workers who left school at fourteen, was asked to report in a collar and tie to appear on a photograph taken outside the New Mill. Tommy remembered the Rigby-Jones family who owned the works as 'smashing people to work for. Everyone got a week's holiday with pay and a small cash gift at Christmas and in those days that was unusual.' Ropes for shipping, farms, church bells, hoists, and even for the shorter sash cords were made in the rope works and a regular consignment of rope was dispatched to HM Prisons. Tommy remembered, 'I don't know what truth there is in it, but we all reckoned at the time that it was for the hangman's noose.'

Between the wars the market was very different from the one we know today. There was a butter market outside the old town hall and the stalls around the clock sold mainly vegetable produce and fruit, except for the one or two that sold pottery. The stallholders continued trading after dark by the light of oil lamps, and the young people used to gather in the marketplace and listen to the sales patter of the various stallholders. On Thursdays, the agricultural and produce merchants would meet the farmers in the Kings Arms and arrange all kinds of deals with them. At Whitsuntide there was an animal fair; horses were sold on Whit Monday and cattle on Whit Tuesday. Afterwards the streets were covered in dung, so the council sent workers to clean up and wash the roadways.

Stoners, who had a shop facing on to the cross, made top hats for those grand occasions, while Cobhams made baskets in the stone building that was to become The Stiles. In his shop in Church Street, Bert Allen recharged the heavy accumulator

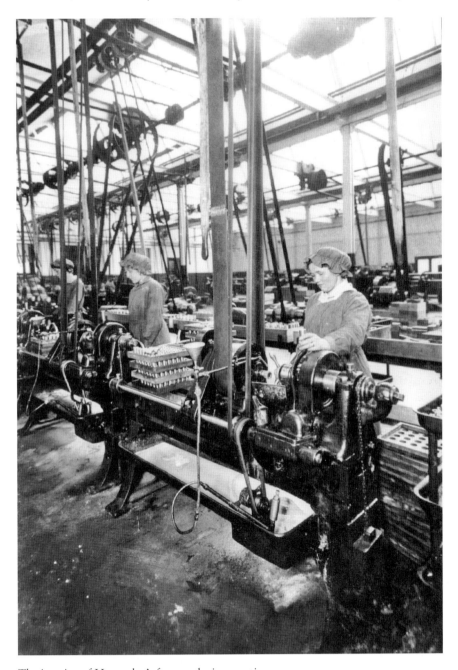

The interior of Hattersley's factory during wartime.

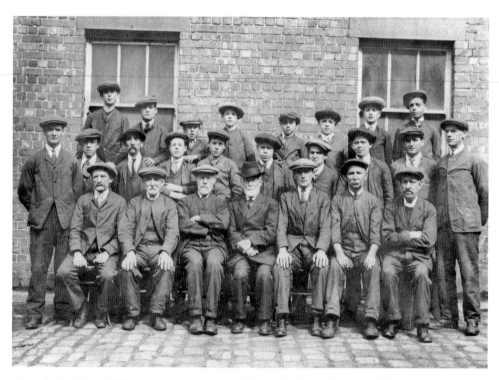

Outside the New Mill at the rope works of H. and J. Jones in 1925. The workers include John Kelly, Joe Flynn, Jimmy Wright, Tommy Scahill, Tommy Jump, Tommy Fairclough, Eric Moorcroft, Paddy O' Riley, Jimmy Riley, Tommy Coleman, Harry Jennion, another Jimmy Riley, young Hatton, Joe Dann, Albert Crompton, Billy Dann, Teddy Crompton, Harry Rothwell, Ted Crompton, the Tittershill brothers, Dick Lea, Bill Tromp, Billy Hambleton, and, of course, Tommy Judge, who named them all.

batteries that were needed for the early wireless sets, which were gradually being introduced into every home. Johnnie Hastings delivered bread from Mawdesleys, and Huttons delivered paraffin, but most of the things that the townsfolk needed had to be collected. In fact, Miss Martin remembered going home from church and seeing ladies carrying jugs of beer from the Snigs Foot brewery, and her father telling her that the jugs could find their own way to the brewery.

One well-known character at this time was Johnny Jennings, the night watchman who had lost his right foot in an accident. His task was to keep watch over any road works that were in process in the district, including the construction of both County Road and Northway. He had a small wooden hut where he could rest after checking that all the warning oil lamps were lit and all was safe for passersby. He started work at five o'clock and finished at eight o'clock in the morning, and during the evening he would heat his dinner on a shovel balanced over the brazier that burnt outside his hut to keep him warm. If he was working anywhere near the gasworks behind Aughton Street, the workers would fill a shovel full of coke

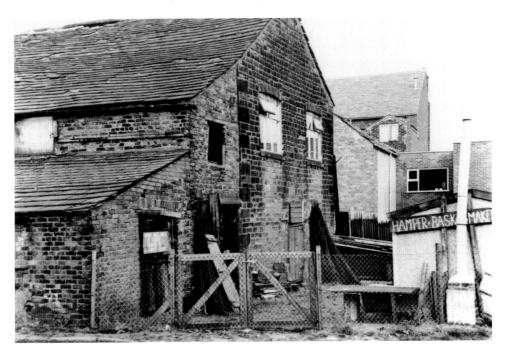

The basket-maker's workshop.

Making baskets inside the stone building which later became The Stiles.

Johnnie Hastings with the delivery cart
from Mawdsley's grocery shop.

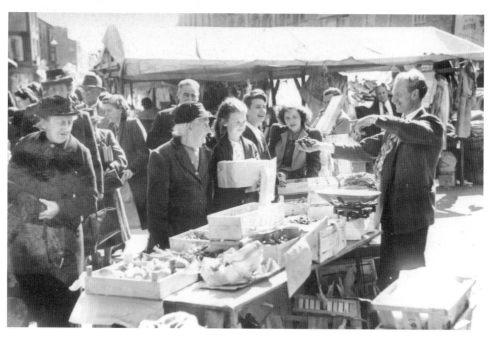

The market in the 1940s.

A very old photograph of Johnnie Jennings outside his watchman's hut.

and bring it out for his brazier. On one occasion, they poured paraffin onto it and caused a minor explosion. Johnnie had also worked as a general labourer at Billy Williams, the pork butcher's shop in Burscough Street, with Jack Jarman the slaughterman.

Johnnie was very fond of animals and bred wire-haired terriers, and one of them used to follow his son Vince to school in Hants Lane, and wait on the step until the children came out. He also bred canaries, and they would lie back in his hand while he washed them with a shaving brush. Another bird that used to amuse the local children was Cocky, a white cockatoo that belonged to Mr Dick Parkinson of Narrow Moss. Each Sunday he used to take his cockatoo outside and put him on the green garden gate. The bird would run up and down along the top of the gate, and when Mr Parkinson said 'Dance Cocky', the bird would bob up and down, much to the children's delight.

Many of the Ormskirk people lived in very small houses with few if any comforts. One group of these cottages was in the cobbled St Martin's Square behind Hants Lane, where families such as the Porters, the Hollyheads, the Crumbleholmes, the Stewarts, the Davies, and the Starchfields lived in cramped conditions. Some

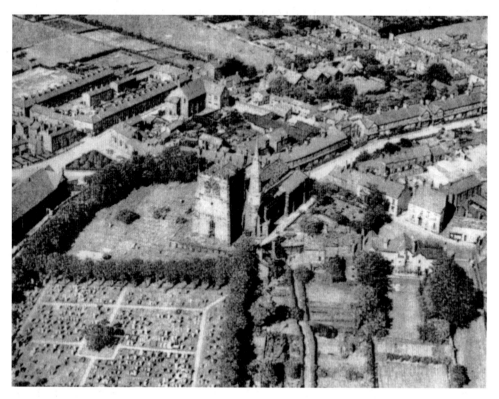

An aerial view of Ormskirk with St Martin's Square and Hants Lane school in the top left hand corner.

of the tenants converted their houses into small shops; for instance, Katy and Maggie Higgins had a sweet shop, while Bob Birchall had a butcher's and Joe Barton kept a food shop. Poverty continued to be a problem, especially in the area around Green Lane, where undernourished children played barefooted in the street.

Mr Marples JP, who lived at the Elms in Derby Street, recognised the need for a proper playground for them and gave a piece of land near St Martin's Square to the children of Ormskirk. It was to be called 'The Children's Peace'. Several years later there was nearly a riot in the town when the council appropriated the playground to build the houses in Pennington Avenue and the clinic on the site. As recompense, they earmarked a field in Green Lane to be a public open space.

My friend's family was typical of many who lived in small cottages on the edge of town, with only two rooms upstairs and two rooms downstairs. In her house there was only one cold water tap, and on washing days rainwater out of the butt had to be carried into the outhouse to be boiled in the copper. Of course, there was no washing machine, only a posser, dolly legs and a rubbing board to use to wash the clothes. There was no electricity, and so flat irons had to be heated on the fire. The privy – the dry toilet – was outside and squares of newspaper hung on a nail to be used as toilet paper in the days before Izal toilet rolls with mottoes in them appeared in the shops. Her mother made mats out of strips of rags pegged onto sacking to cover the stone flags on the floor. In the winter, the beds were heated using either a new brick that had been warmed in the fire oven alongside the grate, or an iron shelf wrapped in an old blanket. At night time a jerry or chamber pot was used, and if they did venture downstairs after dark, they were confronted with regiments of cockroaches scurrying on the floor and around the sink.

The children were given much more freedom to roam and play unattended by adults than they are today. There were certain rules that they had to observe, despite being free to play for hours in the surrounding streets or fields. These limits were impressed upon the children by tales about fearsome creatures that lived in those forbidden places. Jenny Green Teeth lived in the deep water of the pit nearby and would grab any child who went too near. The bogeyman lived in the parlour and he too would catch any child who ventured through the door. My friend had to tell the time by Cadman's green bus as it went once an hour down the road about a hundred yards away from her home. If she did not return home at the correct time, her mother would come and find her, and would strap her all the way home. On schooldays, after returning home, she had to weed rows of carrots on her father's smallholding before she was allowed to go out to play. Similarly, the young Jim Rothwell had to milk the cows and even deliver milk before he went to school. Nevertheless, there was a glorious feeling of freedom for these children, especially at harvest time, when they could play hide and seek among the stooks of corn and were allowed to ride on the wagons and climb on to the top of the haystacks. It was a great day when the Irish labourers arrived at the farm near my friend's home to pick potatoes during the summer months. Jack and Mike Gallagher lived in the

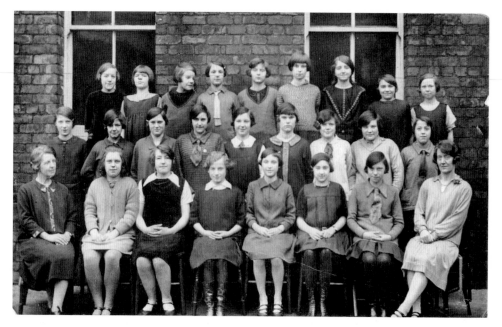

A class in Wigan Road School in about 1927. Left to right, back row: Mabel Cave, Millicent Burt, Barbara Bampton, Beatie Crompton, Doris Farnham, ? Edmondson, Doris Eastham, Lizzie Lowe. Middle row: Doris Can, Nora Hardman, Margaret Lowe, Hilda Ayrton, Norah Collier, Hannah Horner, Doris Stewart, Phyl Crompton, Bessie Caunce. Front row: Miss Liptrot, ? Muriel Dabberley, Margaret Edge, Annie Davies, ? Rothwell, Elsie Rice, Miss Hall.

loose box, the room alongside the stables, and they always had a cheery word with the children. No worry about health and safety in those days.

When the war came, really dangerous games were played. After night raids on Liverpool, the German pilots would sometimes jettison their bombs over the fields of West Lancashire, and the following morning the children would see how many of the brass noses off the bombs they could collect. At the beginning of the war, evacuees were billeted on most of the families in the town, and Derby Street School had to share their building with one evacuated from the danger area. Each school in turn had the use of the classrooms for half a day, while sports and other occupations were arranged for the children for the rest of the day. When lunchtime came, the children went to the British Restaurant in Burscough Street – now Shepherds shop. Whenever the siren sounded, all the children in school had to assemble on the ground floor, sit on their oval coconut mats and wait until the 'all-clear' sounded. Wherever they went, they had to carry their gas masks and had frequent practices at putting them on, hating every minute that their faces were covered by the horrid rubber contraption.

Dr O' Regan and Dr Craig were called up in the Second World War, but they were not allowed to go to war because theirs was a 'reserved' occupation. They were needed to serve on the home front. If there was an air raid on the area, the

Liverpool consultants could not come out to Ormskirk, so when the doctors at the cottage hospital needed help, the consultants stationed at the 12th military hospital at Edge Hill College would go to their aid. That meant that the local doctors served with many distinguished surgeons and physicians, including Colonel Schlesinger, father of John Schlesinger, the film director, and Colonel Aird Davies and Colonel Orr. Fortunately, before the war the cottage hospital had been modernised; it had received major surgical facilities and Mr Littler Jones had been appointed to be the first surgeon. Although it was still dependent on charity, in the late 1930s the hospital had been given an X-ray machine and also an ambulance from the proceeds of a raffle for a small Ford car with a value of £135, donated by Archie Clucas.

Another doctor who served in Ormskirk was Dr Suffern, who was succeeded by Dr R. J. D. Temple. Dr Suffern's rich Irish humour served him in good stead when he appeared in the Gilbert and Sullivan operas that were produced by the Ormskirk Operatic and Dramatic Society, which he had founded. Many townsfolk remember enjoying every minute of such operas as *The Yeoman of the Guard* at the Institute.

Memories of schooldays in the 1940s and 1950s are very vivid for many of today's Ormskirk townsfolk. Old boys remember Aughton Street School, which stood behind the old wall, and still stands alongside the busy Park Road East. One remembered several occasions when Sam Jowett threw the board rubber or the chalk at boys who were not paying attention. Once, when he was annoyed by the cock in a neighbouring garden crowing loudly during his lessons, he took some stones into the classroom and when the crowing started again, he opened the window and threw stones at the cock, much to the amusement of the boys. Then there was Eric Soar, nicknamed 'Scabby', who was very keen on motor cycles. Whenever they got the opportunity, the boys asked him questions about bikes, because then he would soon forget about the lessons. Another master was George Harrison, who taught country dancing in the school. When he became the headmaster of Greetby Hill Church of England School, he continued to teach dancing to an evening class of keen adults. Later on, various restrictions were made on night school classes, and so George formed the local branch of the English Folk Song and Country Dance Society. That group still meets regularly in the Langham Hall today.

Another memory of schooldays at Aughton Street School concerned the boys' toilets that were at the other end of the playground. The water flowed down through the boys' toilets, and finally through the staff toilets. One of the boys' tricks was to set toilet paper alight and watch it float down to the staff toilet in the hope that a member of staff would be at the receiving end.

The teachers at St Anne's Catholic School in Hants Lane are also remembered with gratitude. Miss McCoy looked after the babies, while Miss Cowley was the headmistress. Some of the other teachers were Miss Atherton, Mrs Seddon, Miss Connor, Miss Cammack, Miss Cowley's niece – also a Miss Cowley, Miss Smith, Miss

Ormskirk Musical Association.

President—T. W. COOKE, Esq.

31st SEASON - - 1926-7.

FIRST CONCERT

..IN THE..

WORKING MEN'S INSTITUTE,

..ON..

Tuesday Evening, December 14th at 7-30.

ELGAR'S SYMPHONIC POEM FOR CHORUS AND
ORCHESTRA:

"The Black Knight,"

And Miscellaneous Programme.

Artistes:

MR. FLINTOFF MOORE :: :: BARITONE.

(By permission of The Royal Carl Rosa Opera Co.)

MR. FRED BLUNDELL :: :: :: PIANO.

CHORUS & ORCHESTRA, 1). Leader: MR. H. HASKELL.

CONDUCTOR :. MR. JOHN BALL.

Steinway Concert Grand Piano supplied by R. W. ALRIDGE, Southport.

A programme for the Ormskirk Musical Society's first concert at the Institute.

George Harrison with his friend Jimmy Shand, the accordionist and band leader, with dancers from the Ormskirk English Country Dance club.

A barn dance at the Institute in the early 1950s. The dancers were June Benson, Jack Bibby, Margery Shaw, and, on the left, one of the Howe twins.

Houghton and Miss Knight. Downstairs in the large building were the classrooms for the infants and juniors, while the senior children were taught upstairs. The school had a crèche for the little ones, which was very unusual at that time.

Many of the schoolchildren used to call at the sweet shop in Church Street near The Snigs Foot – now Disraeli's – and buy pennyworths of sweets from Miss Ormesher, known to them as Auntie Polly. Joan Morgan, whose grandmother was a friend of Miss Ormesher's mother, remembered going to the shop when she was about ten. Her grandma, who lived in Halsall Lane, would send her to Polly Ormesher's shop for a packet of five Woodbines in paper packets, and also to Mrs Ryan's house in Hants Lane for a jug of stout. Then they would walk round to Mrs Ormesher's home, which had previously been a pub called the Brickmakers' Arms in Asmall Lane. While the two old ladies enjoyed a glass of stout and a 'ciggy', she used to sit in the corner of the big black settee, counting the roses on the wallpaper and the plates on the plate rack around the top of the walls.

Mrs Ormesher's daughter Polly did not believe in banking the takings from her little shop, but preferred to take them home, despite the police warning her that it was a dangerous practice. As a precaution, her friend Mrs Whitehouse, who lived next door to the shop and called to see her regularly, made a point of walking home with her each Saturday night. On 6 May, she went to the shop and found it locked, and thought Polly must have closed early because it was Cup Final day, and had gone home. However, when she called the following morning and again found the shop locked, she was very concerned and decided to go to Polly's home, Ivydene, in Asmall Lane. As she was very uneasy, she asked the next door neighbour to investigate and what he found horrified him. Polly and her sister lay on the floor in pools of their own blood. They had been brutally murdered, having been attacked with a brass poker, a candle stick and finally with a wine bottle that had been smashed in their faces, making them unrecognisable. The neighbour immediately called the police, who were horror-struck at the sight that met them. Despite making great efforts, the police never found the culprit. Perhaps more evidence may come to light even now and the murderer will be identified. Sometime later, Joe Light, the auctioneer in Aughton Street, a relative of the Ormeshers, who was responsible for sorting out their possessions, found tea chests full of coins from the shop. It would seem that the murderer had not succeeded in finding the shop's takings, if that was indeed his motive in attacking the sisters.

One of the first to know about the murder was Johnnie Houghton, the reporter on the *Advertiser*, who lived in Stanley Street. He was a first-class reporter and an excellent photographer, and so he immediately went to the house in Asmall Lane and took the first photographs of the scene. Reporters from the national papers approached him and asked him to sell some of the photographs to them and he agreed. He decided that as he had taken them, he should profit from his work. The management at the *Advertiser* thought otherwise and dismissed him immediately. However, the *Daily Post* and *Echo* were ready to appoint him and he became the district reporter for those papers.

Demolishing Miss Ormesher's sweet shop shortly after the murder.

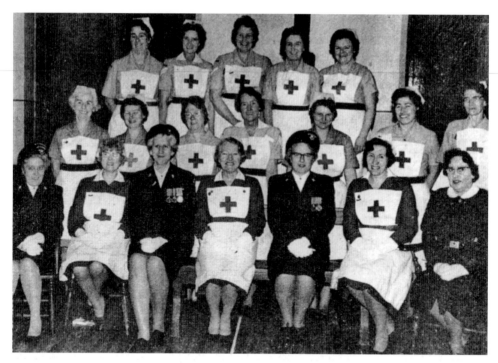

The Ormskirk Red Cross. A group of members of the Ormskirk detachment of the Red Cross, taken in the Langham Hall after their annual inspection in the 1960s. From left to right on the front row are Alice Booth-Taylor, the secretary; Peggy Pogrel, a branch officer from Preston; Jean Ensor, the commandant; another branch officer; Pat Miller; and the nursing officer.

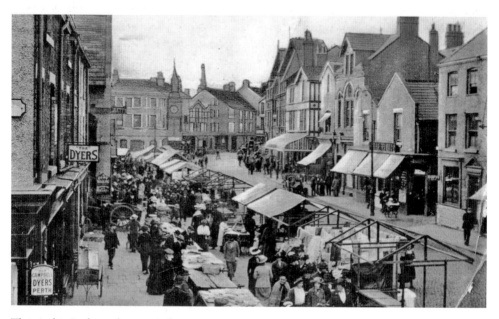

The market in the early twentieth century.

Johnnie Houghton had a small Ormskirk heeler, and every night without fail he would take the dog for its evening walk up Stanley Street and down Derby Street to the police station. The policeman on duty used to give the dog a biscuit and would chat to its owner about the current crime scene. Johnnie achieved his ulterior motive of hearing any news that was just breaking. That was the way he got his scoops – a first-class reporter indeed.

Another murder was committed in Ormskirk on 14 August 1981, when ninety-one-year-old Mr Henry James Walsh, an ironmonger, was stabbed to death in his shop on Moor Street, not far from the bus station. At eleven o'clock on the Thursday morning his neighbour, Mrs Cranson, slipped into his shop to check that he was alright as she often did, but left shortly afterwards because he had a customer. The following morning his daughter in law, Mrs Patricia Walsh, called at the shop, found his body and immediately sent for the police. When they arrived, the police found a carving knife which they thought was probably the murder weapon. Although Mr Walsh was very frail, he had all his faculties, and even though his business was very quiet, he kept his chandler's shop open because he enjoyed meeting people. Three years earlier he had been robbed, and had been taken into hospital suffering from shock. Even after that experience he reopened the shop as soon as he came out of hospital.

Another Ormskirk character who enjoyed meeting people was Stan Draper, the sexton at the parish church, who used to boast that he paid as much attention to the grave of a pauper as to that of a rich man. Every day he went to the hospital to take newspapers round to the wards. The patients would give him their letters to post, and if they needed something from the shops, he would get it for them. He always tried to make their stay in hospital as comfortable as possible. Another task that he set himself was picking up empty pop bottles from the roadside or the hedgerows. When he had collected a number, he would return them to the grocer's shop to get the refund that was offered for empty bottles at that time. No doubt the money would be used to fund some of his good works. His faithful little white Sealyham dog was always with him, usually in the basket on the handlebars of his bike as he cycled around the town. Almost every day he would swim, either in the canal at Halsall from the Saracen's Head to the next bridge, or in the lake in Coronation Park, and when the Park Pool opened he was one of the first to jump into the water.

Another person who spent many years serving the local community was Mrs Mary Duxfield. As the commandant of the Ormskirk Red Cross group, she trained groups of cadets in first aid and home nursing. In 1955, she resigned and her place was taken by Mrs Jean Ensor. Gradually, numbers in the group increased until they had enough support to be able to buy No. 40 Derby Street for their headquarters. A youth group was formed and many a young person has realised that nursing would be a fine career to follow.

Now we have come to the people who are living at present in Ormskirk. What does the future hold for them in the twenty-first century? The focus of the town

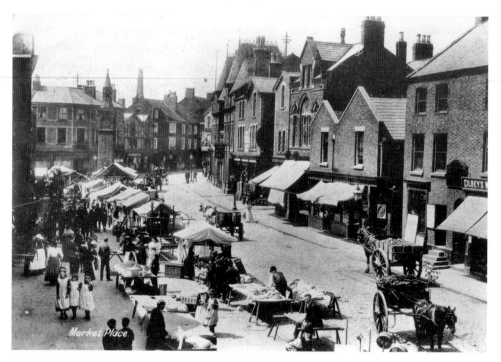

Ormskirk marketplace.

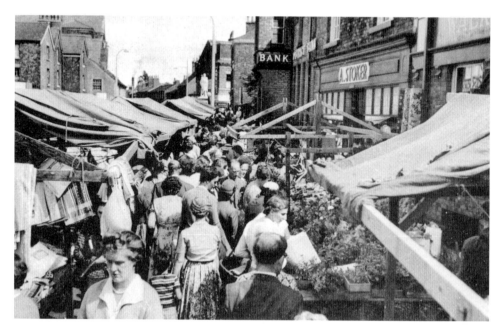

The marketplace in the 1940s.

has changed through the ages – how will it change now? In the sixteenth century, it was dominated by the Church; in the seventeenth century, the Civil War and its aftermath affected the people. During the eighteenth century, the people of the Georgian era changed the appearance of the town, and in the nineteenth and twentieth centuries public health was their major concern. The promotion of Edge Hill College into a university and the resulting increase in the student population has changed the focus of the town yet again. Of course, most of the students will move after a few years, but inevitably they will alter the economy of the town. Again, the Ormskirk people will adapt to this new influx of strangers, as they did when the Irish flooded into the town in the 1840s. Echoes of the past remain. The churches continue to play an active part in the town, the health services strive to improve people's lives, the local politicians continue to promote their own agendas and the market survives through it all. Progress continues and yet paradoxically nothing changes in Ormskirk.

Notes

1. I am indebted to Dr Nigel Neil for the information on the remount depot. Richard Houghton researched the careers of the soldiers named on the certificate. The rest of the information in this chapter has been garnered from friends in the district and from newspaper reports in the *Advertiser*.

ALSO AVAILABLE FROM AMBERLEY PUBLISHING

MONA DUGGAN

ORMSKIRK

THROUGH TIME

Ormskirk Through Time
Mona Duggan

ISBN 978 1 84868 674 8
96 pages, full colour throughout

Available from all good bookshops or order direct
from our website www.amberleybooks.com